THE ALFRED
JEWEL

ASHMOLEAN HANDBOOKS

THE ALFRED JEWEL

AND OTHER LATE ANGLO-SAXON
DECORATED METALWORK

DAVID A. HINTON

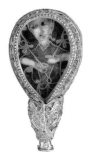

ASHMOLEAN MUSEUM

The Alfred Jewel and Other Late Anglo-Saxon Decorated Metalwork

Copyright © Ashmolean Museum, University of Oxford, 2008

David A Hinton has asserted his moral right to be identified as the author of this work.

British Library Cataloguing in Publications Data

A catalogue record for this book is available from the British Library

HB: EAN 13: 978 1854 442291 (ISBN: 1 85444 229 5)
PB: EAN 13: 978 1854 442307 (ISBN: 1 85444 230 9)

Catalogue designed by Geoff Green

Typeset in Goudy

Printed and bound in the UK by Cambridge University Press

OTHER TITLES AVAILABLE:
The Arundel and Pomfret Marbles by Michael Vickers
English Embroideries by Mary M Brooks
Japanese Decorative Arts of the Meji Period by Oliver Impey and Joyce
 Seaman
Michaelangelo and Raphael Drawings by Catherine Whistler
Oxford and the Pre-Raphaelites by Jon Whiteley
Ruskin's Drawings by Nicholas Penny
Samuel Palmer by Colin Harrison
Watches in the Ashmolean Museum by David Thompson

For further details of these or any of these titles please visit:
www.ashmolean.org/shop

Ash*The*molean

Contents

Preface and acknowledgements

The Alfred Jewel is probably the single most famous archaeological object in England. Its distinctive shape, the valuable materials used to make it and above all its tantalising inscription that may refer to King Alfred (871–99), the only English king to be called 'the Great' – not until the thirteenth century, though his memory was already held in high regard by the beginning of the eleventh – has a fascination that nothing else can rival, even the great treasure found in the seventh-century ship burial at Sutton Hoo, Suffolk, which is celebrated as a collection rather than for any individual object in it.

The Jewel has received much attention from scholars since its discovery in 1693, and continues to be discussed in work on the Anglo-Saxon period. The Ashmolean Museum produced a booklet on the Jewel in 1948, written by the late Mrs J. R. Clarke, and she and I collaborated on a revised edition in 1971. Thirty-five years later, I am glad to have the opportunity to write this much longer handbook, which reviews recent ideas and the significance of new discoveries, and presents pictures and descriptions of other things relevant to the Jewel's study.

The Handbook focuses on the collections in the Ashmolean that date to the ninth, tenth and eleventh centuries AD, but also illustrates objects in other museums; these pictures are reproduced by kind permission of the Trustees of the British Museum (the Bowleaze Cove jewel, the Aughton aestel, the Fuller brooch and the two royal finger-rings), the Trustees of the Salisbury and South Wiltshire Museum (the Warminster jewel), Lofotr Viking Museum (the Borg *aestel*), Warwickshire Museum Service (the Bidford

object), the owner of the Aughton *aestel*, the Curators of the University Libraries, University of Oxford (Oxford Bodleian Library MS Hatton 20), Trinity College, Dublin (Book of Kells), and the City of Winchester Museum Service (Winchester reliquary). I should like to thank the curators and directors of those museums, Leslie Webster, Peter Saunders, and Sara Wear, as well as several other friends and colleagues for their help. Most of the superb line drawings are by Pat Jacobs, and were done for the catalogue of the Ashmolean's collection that was published in 1974. Others are by Marion Cox (Reading sword) and Nick Griffiths (the Cranborne Chase strap-end). All photographs not otherwise credited are the copyright of the Ashmolean Museum.

Thanks are also owed to Arthur MacGregor and Barbara Yorke for their helpful comments on the text, and to Nick Mayhew for augmenting the section on coins, as well as to Hilary Walford for meticulous copy-editing and the staff of the Publications Department of the Ashmolean for seeing this Handbook through production.

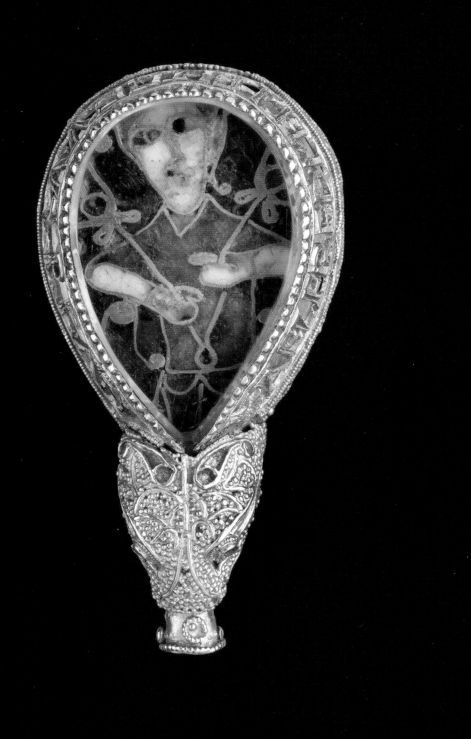

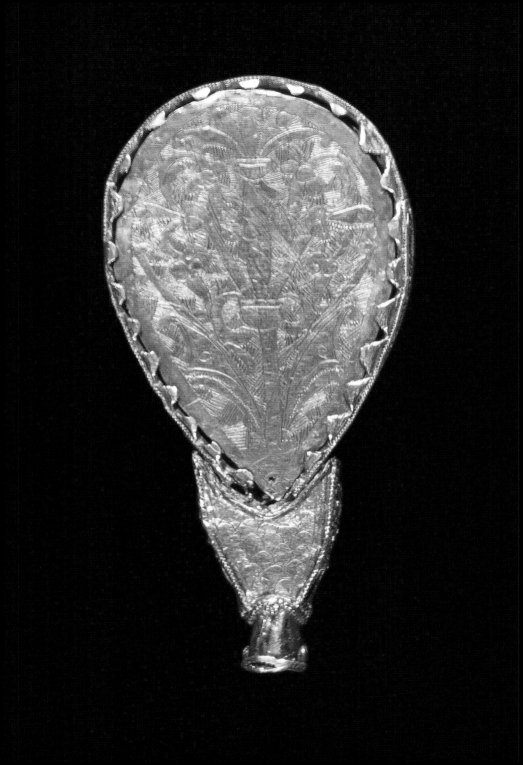

1. The Alfred Jewel

Discovery

The Alfred Jewel was found in 1693 by a labourer whose name is unknown. He was digging for peat in the south Somerset moors at Newton Park in North Petherton; the moors have since been drained, and he was probably working in what is now a field unromantically called Forty Acres (ST 310321). Newton Park is about four miles from Athelney, where in 878 King Alfred sheltered from Viking invaders (and in later legend burnt the cakes), before rallying his people and winning a great victory at Edington in Wiltshire. South Somerset was also the setting for the Treaty of Wedmore, which led to the Vikings leaving Wessex. As a thanksgiving, Alfred later founded a monastery at Athelney.

Newton Park was owned by Sir Thomas Wrothe, who became the owner of the Jewel. He soon gave it to his uncle, Colonel Nathaniel Palmer, who had been an undergraduate at one of the Oxford colleges, Trinity, and at his request it was given to the University after he died in 1717. It was supposed to have gone to the Bodleian Library, but in fact entered the collections of the Ashmolean Museum, opened a few years earlier and the first public museum in Britain.

The Jewel was received by the Ashmolean in 1718 from Thomas Palmer, Nathaniel Palmer's son, whose initial is shown with it in the watercolour painting in the Museum's 'Founder's Book'. The picture emphasizes the inscription cut into the Jewel's gold frame. The first word, after an introductory cross like those used on coins and seals, is 'AELFRED'.

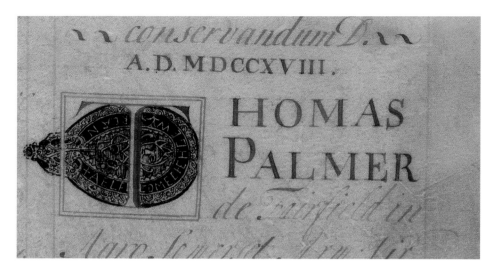

Description

The Jewel has three components: gold, a shaped and polished rock crystal, and *cloisonné* enamel, which is coloured glass set in a honeycomb of gold to make a pattern.

The gold consists of a teardrop-shaped frame through which the letters of the inscription were cut, AELFRED MEC HEHT GEWYRCAN, 'Alfred ordered me to be made'. Below the letters, gold wires were soldered on to the frame in an elegant arcade and scroll pattern, with gold grains filling the spaces. The arcade is framed by beaded gold wires. At the end is a sheet-gold animal's head, with gold wires forming its long scrolling ears, eyes with beaded wires that probably once held small blue glass studs, long scrolling eyelids, and jaws, in which it clasps a short tube. Through the end of the tube is a gold rivet, widened at its ends to stop it falling out. The tube is empty and has no trace inside it of whatever was originally held in place by the rivet.

The donation of the Alfred Jewel to the University of Oxford was recorded in the Ashmolean Museum's 'Founder's Book' in 1718

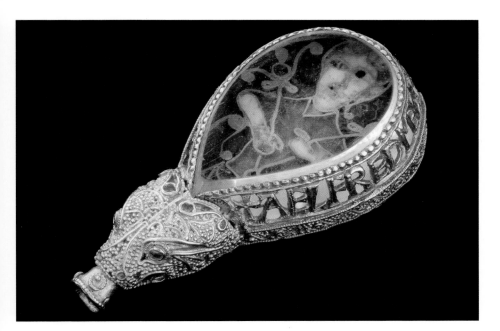

Enlarged picture of the Alfred Jewel, showing the first word of the inscription, 'AELFRED'. The eyes in the beast's head may originally have held blue glass studs like those on the Bowleaze Cove and Warminster jewels (see pp. 33 and 34)

Actual size photograph of the back of the Jewel's frame; a little of the goldwork has been damaged at this point

The back of the beast's head is a separate gold sheet, soldered into place by a beaded wire. It is engraved (or chased – there is a slight difference that is hard to detect) to look like scales. A larger backplate is secured by 'teeth' extended from the frame and bent over. This plate is engraved with an elegant plant pattern – a central stem has leaves and branches sprouting out from its sides and top – against a hatched background. The enamel is fused on to a separate sheet.

The workmanship of the gold is good, but not outstanding. Some of the solder 'flooded', and was not then melted out. The grains are a little coarse, and the arcaded wires are not perfectly even. Some of the wires are beaded, but the more skilful twisted wiring was not used. The engraving on the backplates is surprisingly careless, with lines cutting over others, and curves very obviously done freehand.

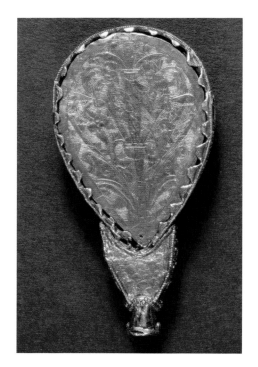
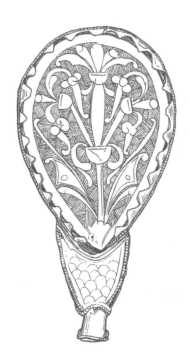

The condition of the Jewel is very good, but a piece of beaded wire and some of the granulation have been lost from the back of the frame – consequently it can be seen how the gold was slightly roughened to help the solder to adhere. The head seems at some time to have been dislocated and reset without getting the join quite right. (Packing between the visible back-plate and the plate behind the enamel shows that the Jewel has been disassembled since its discovery, per-haps when replicas were made at the end of the nineteenth century, but no record survives.)

The gold is about 84 per cent pure, typical for the later Anglo-Saxon period when the metal was valu-able but not unobtainable – it had to be imported, and possible sources include the Near East, the south of France, and Spain. Its colour suggests that some

Enlarged photograph and drawing of the back of the Jewel. The plant on the larger sheet is ele-gantly designed but less well executed

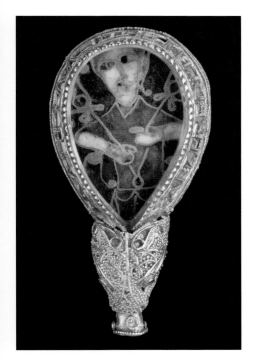

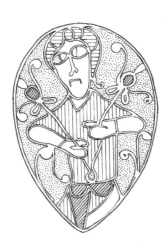

Because the crystal in the Jewel is bevelled, the enamel behind it cannot be seen clearly in a single photograph. The drawing shows the whole composition

silver is alloyed with it, as was indeed the norm with medieval work to make the gold more durable. Mercury, needed for the soldering, must also have been imported.

The crystal is a natural quartz, the source of which cannot be definitely established. It has been skilfully cut to shape, with bevelled sides so that the base is wider than the top. After cutting, it was polished with coarse grit, which has left very fine striations in the surface, almost invisible to the naked eye.

The crystal must be older than the rest of the Jewel, as the gold frame covers some tiny chips (see p. 23). There has been some modern repolishing, per-haps done when the Jewel was first found, or when it was taken apart.

The enamel is glass of different colours: blue, green, red, and white. Because of the crystal above them, the enamels cannot be analysed to see what the different colours are composed of. The white is probably antimony, a tin mixture. They are separated by thin gold strips, soldered to a gold backplate. These cells ('cloisons') would have been made first, and were then filled with glass, melted and made into a malleable paste that would fuse into place when gently heated.

Cloisonné work is very skilful; heating the enamel to fuse it, for instance, risks melting the solder that holds the gold cells in place. A simpler method is *champlevé*, which involves cutting or casting the patterns from solid metal (for examples, see below). Another is to use small pieces of flat glass as inlays, cut to shape to fit into their cells, a technique also used for red garnets in the Anglo-Saxon period.

Originally thought to be Byzantine work, and later ascribed to Italy, the enamel is now thought quite likely to have been made in England. Wherever the craftsman trained – perhaps on the Continent in the Carolingian world, modern France, the Low Countries or parts of Germany – he was working to a commission; he had to make the shape of the enamel conform to the shape of the crystal that was to go on top of it.

The design of the enamel forms a seated figure wearing a green short-sleeved tunic with a V-shaped open neck. The head does not have a beard, but seems to be male with rather long curly locks – a female figure would almost certainly have been shown with the hair covered by a hood. The pose is informal, with the head slightly to one side. In each hand the man is grasping two flowering plants that sprout from a bulb that echoes the shape of the Jewel itself. His arms seem to rest on the arms of a stool – it is not a throne as it has no back. One of the arms is simply a two-leaved plant stem, while the other looks curved but

more solid. The lower part of the body may be showing truncated legs, but the lack of clarity here has led some people to suggest that the enamel was originally larger and was cut down to fit under the crystal. It would have been very difficult to do this and then solder on a new surrounding gold strip, however, and the way that the plants and the top of the man's head touch the framing line suggests that they were designed as an entity.

Early descriptions and discussions

The first illustration of the Alfred Jewel appeared in volume 20 of the *Philosophical Transactions of the Royal Society* for 1698 (overleaf), a journal in which some of the most important scientific and medical discoveries of the second half of the seventeenth century were published. Characteristic of the wide-ranging sense of enquiry and experiment of the time is that the picture of this 'curious piece of Antiquity' appeared on the same page as diagrams illustrating 'Some Experiments and Observations concerning Sound' and a drawing of 'A Stone bred at the root of the tongue and causing a Quinsie'. The picture is incorrect, as the image of the figure is reversed; the frame is flattened out to show the letters, for it was the inscription that led to most of the early scholarly attention.

The author of the paper in the *Philosophical Transactions* was Dr John Musgrave. He speculated that 'this was, perhaps, an amulet of King Alfred's', but he noted that, because the workmanship was 'very fine', 'some Men question its true Age'. Its authenticity, however, is not now in doubt; no one faking it in the seventeenth century could possibly have anticipated all the subsequent discoveries (many in this Handbook) that confirm that it could only have been designed and made in the Anglo-Saxon period. More

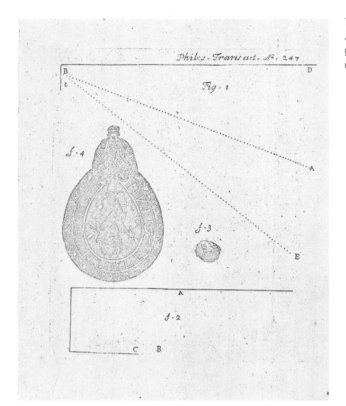

The first illustration of the Alfred Jewel, published in 1698 (photograph by courtesy of the Curators of the Bodleian Library, Oxford)

problematic is the inscription, and whether it really refers to King Alfred.

The inscription

By the time that it reached Oxford in 1718, the Jewel was already well known. Musgrave was one of four Oxford fellows who had published papers about it. Another was Dr George Hickes, a linguistic scholar who used the inscription to confirm his theory that one of King Alfred's achievements had been to alter the style of English lettering, something that most people do not now accept.

The letters around the frame are Latin capitals, but the text is Old English: AELFRED MEC HEHT GEWYRCAN, 'Alfred ordered me to be worked (made)'. Enough texts written in Old English survive for dialects to be recognizable; in this case, the second and third words are more typical of work written in Mercia (the Midland kingdom) than in Wessex, which King Alfred ruled. That might be an argument that it was not made for him, except that he had at his court scholars from various countries, including some Mercians, and craftsmen 'in almost countless quantity from many races', who were 'skilled in every earthly craft', according to his biographer, Asser, himself a Welshman. The Mercian and Wessex kingdoms cooperated in various ways, including over their coinages (below).

Much more problematic is that the word *cyning*, Old English for 'king', does not appear in the inscription. More than one of King Alfred's contemporaries shared his name. One was an *ealdorman* in Kent, a leading figure who was rich enough to ransom a valuable book from Viking raiders. Another Alfred, although also an *ealdorman*, was castigated as 'foolish'

by the Bishop of Winchester, because he 'libidinously committed debauchery'. King Alfred always used *Rex*, Latin for 'King', on his coins, with the sole exception of some minted in Gloucester and Oxford, both technically outside his kingdom though not beyond his influence. In vernacular texts such as the *Regula Pastoralis* that were written on his initiative, he would be *cyning* or a variant of it. Even on one occasion when he began a letter to his bishops simply with 'Alfred', he immediately went on to call himself 'honoured with the dignity of kingship'. If he commissioned the Jewel, why did he not insist on including his title in the inscription?

The enamel figure

Many different theories have been put forward to try to identify the seated figure shown in the enamel. Some round continental brooches have enamel figures, thought to be saints. Other parallels have occasionally been drawn – for instance, with a head picked out in garnets on the shield excavated in the seventh-century Sutton Hoo ship burial, and the Fuller brooch (opposite) has human figures, but nothing in paintings, sculpture, or other metalwork is really like the Jewel's seated man.

Musgrave in 1698 thought that the figure was a picture of King Alfred himself, and others have agreed, although a king would normally have been shown in imperial costume with a diadem, wreath, crown, or helmet on his head, depending on the period (see coins, p. 87). Hickes wondered if it might be Christ, but in the end opted for St Cuthbert, then thought to have been one of King Alfred's patron saints, and saw a similarity to the figure of St Luke in the eighth-century Book of Lichfield.

The Book of Kells, probably painted in Ireland in

Detail from the Book of Kells
(Trinity College, Dublin)

The figure of Sight in the centre of
the Fuller Brooch (see Brooches.
Photograph by courtesy of the
Trustees of the British Museum)

the ninth century, has a scene showing the Christ
child in the Temple precociously debating with the
Elders, and holding two crossed staffs. The colouring
of the picture suggests the bright tones of the enamels
of the Jewel. The figure may, therefore, be the young
Christ, representing the wisdom that he showed in the
Temple. A problem with interpreting the figure as
Christ or one of the saints is that there is no halo
behind the head, but Christ is not invariably shown
with one. As the figure is sitting, it may be intended
also to represent Christ in judgment, though a for-
ward-facing head would be more usual in that case, as
on the Sandford reliquary (see p. 88).

The other favoured interpretation, proposed by Egil
Bakka in 1966, is that the figure is Sight. Five figures
representing the Five Senses are shown on the Fuller
brooch, probably made at much the same time as the
Alfred Jewel, with Sight, the most important and with
staring eyes to emphasize the meaning, at the centre
(actual size detail shown left; see p. 63 for the whole
brooch). The two flowering branches that Sight holds
are comparable to those held by the figure on the
Jewel. In both representations, the penetrating eyes
are a reminder that Sight is necessary for reading, and
that from contemplating the words that have been
read comes wisdom; Sight can therefore be an allegory
for Christ.

David Howlett suggested in 1974 that the two
stems that the Jewel's figure is holding, springing from
a bulb, could allude to Aaron's rod in the Old
Testament, which flowered in the Tabernacle,
becoming two stems that are interpreted as Truth and
Wisdom; the figure's clothes suggest priestly vest-
ments, as described in the same text. Howlett was the
first to propose a coherent programme for the whole
design of the Jewel, the beast's head reminding
Christians of Satan, whose cunning is the perversion

of wisdom, and the plant on the main backplate being the tree of life, which in the Old Testament is an allegory for wisdom, and becomes the Cross in the New.

The crystal

Because it was not new when set into its frame, the shape of the crystal dictated the overall shape of the Alfred Jewel.

Polished crystal has a fascination because it is translucent, and many beliefs are attached to it: that it can be used to see into the future is a favourite. That smacked of paganism to Christian writers, but healing and protective powers could be permitted to it, for those were properties bestowed on the quartz by God. The 'white stone' sent as a gift to King Alfred by the Patriarch of Jerusalem to cure his illness might therefore have been a crystal. A deeper Christian belief in the Middle Ages, however, arose because Classical writers had said that crystal was pure water hardened by exceptionally severe freezing. That made crystal symbolic of the purity that is bestowed by baptismal water. Catherine Karkov in 2004 pointed out that the great eighth-century English scholar Bede had noted that 'crystal' sounds like the Old English word *cristsmael*, meaning Christ's Cross, making the stone exceptional for its visual closeness to Him. Matthew Kempshall in 2001 drew attention to a text by Pope Gregory, whose work was certainly known to Alfred (see p. 28), likening cut stones to writers who teach by example, and that the Book of Revelation speaks of a throned figure in heaven behind a 'sea of glass like unto crystal'.

His scholars would have explained the Christian significance of crystal to King Alfred, because it was expounded by Carolingian writers in the late eighth and ninth centuries. Carolingian craftsmen produced

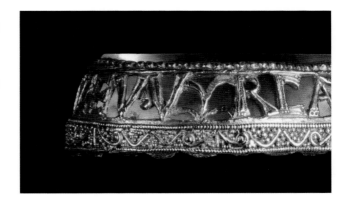

a number of large polished crystals engraved with biblical scenes. None of those that survive is like the Alfred Jewel's crystal, however. In shape it is most similar to a triangular polished crystal excavated in Northampton in 1977, but that is not flat backed.

The best explanation of the source of the pre-shaped crystal in the Jewel was given by Genevra Kornbluth in 1989. She showed that the closest parallels are Roman classical gemstones in the Vatican collection in Rome. They were used as wall decoration or as inlays on furniture, and some are the same shape as the Alfred Jewel, even to having bevelled sides. How could a classical crystal have reached ninth-century England? The Anglo-Saxons had a particular affinity with Rome and the Papacy, because it had been Pope Gregory who had sent St Augustine from the Holy City to convert England. Among the many pilgrims who went there were kings, and as a child Alfred probably accompanied his father on a mission to the Pope. Gifts were regularly sent, and occasionally some came in return. Pope Marinus in 883 sent a piece of the True Cross to King Alfred, for instance. Was the crystal one of the other papal gifts that are recorded but not described, subsequently set by the King in a frame that honoured the Pope's

present with suitable magnificence? Alternatively, it could have been a gift from some other important international contact: the Carolingian court, or the Patriarch of Jerusalem.

The beast-head terminal and the nozzle

Animals featured in Anglo-Saxon art in many guises. Boars were much favoured, because the fierce courage of the beast symbolized the expected behaviour of a warrior, and the thick skin of the animal made it suitable as a protective symbol on a helmet. Ravens that feed on carrion can refer to the dead men slain by a successful sword (compare the Abingdon sword, p. 54). The animals are not often anatomically recognizable, however, as they were images of dragons, the *wyrm* of many texts. Consequently, as David Howlett pointed out, they can stand for the devil that threatens Christianity, and on the Jewel the creature may specifically represent the forces of destruction that threaten wisdom and Christ's word. Certainly, the scales on the back suggest some monster more snake-like than animal-like.

The short tube gripped in the beast's snarling jaws is made of thin gold sheet. The rivet passing through it is solid, but whatever it held in place would not have withstood much wear and tear (see drawing on p. 19). Other objects with similar fittings are described below; none has any other means of attaching it to something else, such as a brooch would have, for instance.

Sculptured stone heads very similar to that on the Jewel are in the Anglo-Saxon church at Deerhurst, Gloucestershire, where they appear beside doorways and the chancel arch – perhaps symbolizing the threats of damnation in Hell that the faithful avoid by entering the church and the sacred spaces inside it.

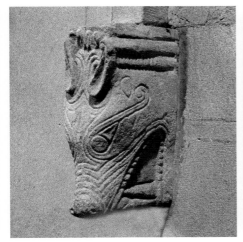

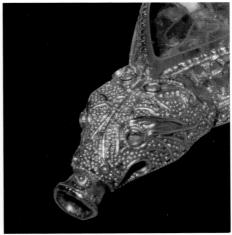

Sculptured stone head in the church at Deerhurst, Gloucestershire. It would originally have been painted (author's photograph)

Enlarged view of the beast's head on the Alfred Jewel

Recent work at Deerhurst puts these heads into a ninth-century building phase. Another parallel is the Pakenham spur (see p. 79).

The back

Behind the beast's head is a scale pattern, perhaps indicating the creature's snake-like qualities as a *wyrm*. David Howlett's suggestion that the plant on the main panel should be taken as the tree of life would create a link to the Old English poem 'Dream of the Rood', in which the tree that was cut down to make the Cross takes on life and speaks.

The function of the Alfred Jewel – an aestel?

Most Anglo-Saxon precious-metal objects have obvious uses – brooches, sword fittings, and so on (some of these are described later). The Alfred Jewel is different; the tube and rivet suggest that something was fitted into it, such as a short wooden or ivory rod, or it was attached to something, such as on to a peg at

the end of a sceptre. Anything like that would have had to be drilled through to take the rivet, so would have been left very weak, even if a fine enough borer could have been made. Any explanation also has to take into account both the flat back and the relative weakness of the gold sheet forming the animal's head, as well as the Jewel's shape and inscription.

If the lack of the royal title does not stop the Jewel from having a direct connection to King Alfred, then something connected to him in some way is the obvious starting place for discussion of its purpose. For instance, he had various books translated from Latin into English, so that more people would understand them – after the Viking raids the Church needed reviving, and not all the priests were well enough educated to know Latin; the King wanted to ensure that everyone in his kingdom could hear the Word of God. One translation was the *Regula Pastoralis*, a book of instruction for rulers and priests originally written in the sixth century by Pope Gregory.

To emphasize the importance of Gregory's work, Alfred sent a copy of his translation to each of his bishops, with a covering letter to explain why he had chosen it. He went on to say that he would also send with each book an *aestel*, worth 50 *mancuses* (equivalent to 1,500 pennies), and that no one was to take the *aestel* from the book. He did not explain what an *aestel* was for, so presumably his bishops would have known; unfortunately, nowadays we do not. The word is Old English, may originate in the Latin *hastula*, 'little spear', and in the eleventh century was used to translate the Latin word *indicatorium*, 'pointer'. The *Regula Pastoralis* lays stress on both wisdom and *wela*, 'wealth'; was this represented by the Jewel both physically as a valuable object and metaphorically as an aid to understanding God's wealth that is stored in books, and is better than worldly treasure?

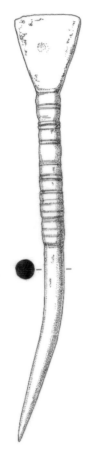

Copper-alloy stylus bought in Abingdon. Apart from the ribbing, it seems not to have had decoration, unlike some that have a silver panel set in the triangular head; actual size is 125 mm long

An Oxford fellow, Thomas Hearne, suggested in 1711 that the Alfred Jewel was an *aestel*, and one of the royal gifts to the bishops. He did not know the word's origin or translation, however, and took it to be the same as *stylus*, a metal or wooden point used to write on wax tablets or to rule lines on parchment. Hearne saw the Jewel as fitting on to the top of one. That is possible, but the surviving *styli* have triangular ends so that they can also rub out mistakes or smooth the wax surface for the next writer, like this one bought in Abingdon, Oxfordshire; its stem is bent, from later damage. Something as heavy as the Alfred Jewel on the end would make a stylus very top-heavy and less useful as a writing implement.

Hearne's final thought was that an *aestel* was the terminal of a rod around which a manuscript was rolled – he suggested that the Alfred Jewel had been fitted on to the roller for a copy of the *Regula Pastoralis*. This is also a possible use, though the tube is so narrow that it is unlikely that it would have been robust enough to fit on rollers that would often get handled – and Alfred said explicitly that the *aestels* were to stay *ón aelcre bok*, meaning something more specific than that it was merely part of some ancillary fitting.

Objections raised against the proposal that the Alfred Jewel was one of King Alfred's *aestels* have included the very reasonable one that the King's letter says that each was worth 50 *mancuses*, theoretically $7\frac{1}{2}$ ounces of gold, while the Jewel weighs only $1\frac{5}{8}$ ounces. But Alfred probably meant simply that what he was sending was very valuable – anyway, the bishops were unlikely to dare to complain! Similarly, North Petherton is a long way from any bishop's church – but it is near the King's monastic foundation at Athelney. Surely he would have sent a copy of his book there, even though monks did not have direct

parochial responsibility for the 'care of souls'? And for the King's own church, only the most splendid *aestel* would have been good enough.

Hearne's idea was largely ignored, but everyone accepted that the Alfred Jewel had been made for the great king. So ideas circulated that it had been part of his crown – though he may never have worn one; that it had been at the head of a battle standard – from which it would soon have fallen off under the strain of being waved around; that it was worn on a chain around the King's neck – possible, though it would have been in constant danger of being lost if a gold link gave way under the weight; or that it was a state jewel on some staff of office – more possible, since it

would have had considerably less strain from being moved around if used only on special occasions, of which unfortunately there are no direct descriptions. Nor would something on the end of a staff have had an off-centre attachment and sloping sides, which would have unbalanced it and made it more likely to fall off.

A bishop of Bath and Wells, W. J. H. Clifford, seems to have been the first to suggest a different interpretation of *aestel*, in 1877. He noted that in the thirteenth century the Latin words *festuca*, 'rod', as well as *indicatorium* had been written above the Old English word in Alfred's preface, and suggested that it was indeed a 'pointer', to be used by someone reading a manuscript, stopping to ponder a word, or translating from one language into another. The flat back meant that it would lie easily on a page – an ideal aid for someone involved in King Alfred's work.

2. Other possible aestels

Many objects have some similarity to the Alfred Jewel, but few have the same sort of tube with a rivet through its end.

The Minster Lovell jewel

In 1869, the Revd J. Wilson gave the Ashmolean Museum an object that an Oxford dealer had sold him; apparently it had been bought in about 1860 from a labourer who said that it had been found in Minster Lovell, Oxfordshire. Nothing has ever been found to confirm or deny this account.

The Minster Lovell jewel does not have a piece of rock crystal, but it has a round *cloisonné* enamel at the top of a bevel-sided frame, and a flat-backed tube, with rivet holes at the end. The rivet has disappeared,

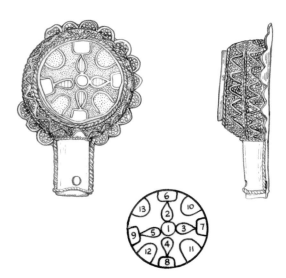

Drawings of the Minster Lovell jewel, slightly enlarged

Enlarged view (see also end of book)

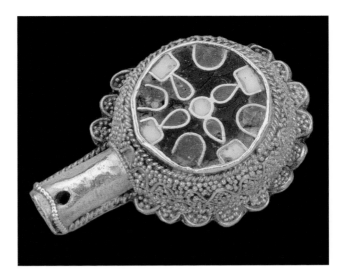

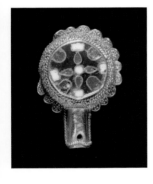

Front view of the Minster Lovell jewel, actual size (see also p. 94)

and as with the Alfred Jewel, has no trace inside of what fitted into the tube. Instead of having 'teeth' turned over to hold a backplate in place, the sides of the Minster Lovell jewel are turned out at the base to create a wavy edge, now partly broken. The backplate is quite plain; it is soldered on, so there was never an intention that the space behind the enamel could be used to keep a small relic or something inside that could be taken out from time to time.

The design on the enamel has to be looked at twice to see what it represents. The semi-circular light-blue cloisons, 10–13 on the drawing, contrast with the dark-blue background to form a symmetrical round-armed cross. As Dr Bakka pointed out in 1966, this is an 'Anglian' cross form, often used in Anglo-Saxon England. The pear-shaped green cloisons, 2–5, can perhaps be seen as a second cross 'disguising' the first, so that anyone looking at it has to look more deeply to ponder the work's meaning.

The quality of the enamel and the gold cloisons is very similar to the enamel in the Alfred Jewel. So also

is the goldwork; it has the same plain wire arcading and granulations, though not the scrolls, and it has twisted filigree wires as well as a beaded one. The bevelled sides and the flat back suggest that it had the same function, and it could have sat easily on the page of a book.

If this object really came from Minster Lovell, it was not found as close to a major church as the Alfred Jewel was to Athelney. Eynsham, about seven miles east, is probably the closest, but it was not a bishop's cathedral and did not become a formal abbey like Athelney until refounded as a Benedictine house in 1005.

One other object has enamelwork that is comparable to that on the Minster Lovell jewel; a gold finger-ring found in 1984 at Lytchett Matravers, Dorset, has an 'Anglian' cross overlaid by a second cross with pear-shaped arms. But no recent finds have quite the same goldwork as the Alfred and Minster Lovell jewels; their craftsmanship strongly suggests that they were produced at the same time and in the same workshops for an exceptionally rich patron – who else could that have been but a great king?

Five recent finds

During the 1980s, excavation of a chieftain's house at Borg on an island off the coast of northern Norway produced evidence of high-status use. This included the discovery of a pear-shaped object made of sheet gold, ending in a tube. It is flat backed, with the tube on the same plane, so that it could have sat on a flat surface just like the Alfred and Minster Lovell jewels. It also has beaded gold wires like them, but forming a symmetrical pattern, without any enamel. At the back are two small attachment holes, and there is no rivet through the tube, nor holes for one.

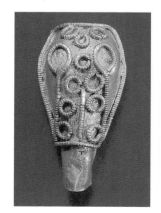

Front view of the object excavated at Borg, Norway; actual size is 25 mm long (photograph by courtesy of the Lofotr Viking Museum, Tromsø)

North Norway is so far from England that any contact with King Alfred and Wessex might seem unlikely, but it is recorded that a merchant called Ohthere was a visitor to Alfred's court, trading in walrus ivory. He lived even further north than Borg. Why should a merchant like him have wanted or been given such a strange piece of gold? He was not a Christian, so would not have understood any holy meaning that it might have had or how it could be used in reading and writing. He might perhaps have prized it if it had been given him by the great king, but how did it come to be in a place with which he is not known to have had a direct connection? Perhaps it did not come from Wessex, but had been stolen in a Viking raid on a church somewhere in western Europe – but in that case, a few examples might be expected still to have survived in church treasuries, as have some reliquaries and other ecclesiastical works of art.

The next discovery of a flat-backed gold object with a tube was made by a metal-detector user, who reported in 1990 that he had found it among fallen cliff debris at Bowleaze Cove, near Weymouth, Dorset.

The Bowleaze Cove jewel; actual size is 31 mm long (photographs by courtesy of the Trustees of the British Museum

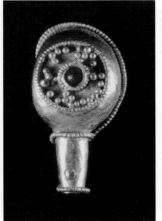
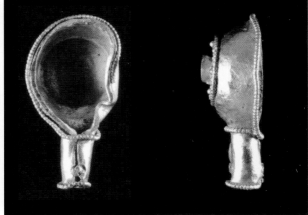

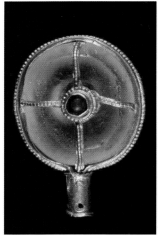
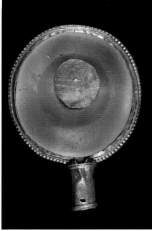
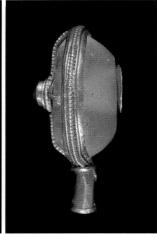

It is now in the British Museum. Metal-detecting has produced a great number of archaeological finds in the last forty years, and when these are reported responsibly to the Portable Antiquities Scheme, and are not taken from known sites or from below modern plough depths, can be major additions to knowledge.

In shape and size the Bowleaze Cove jewel is remarkably like the one from Minster Lovell, but does not have enamel or the same complex goldwork. Instead, the top has an apparently random scatter of gold granules around a small central blue-glass domed stud held in a beaded wire gold collar. Its nozzle is not flat backed and is slightly conical. It has lost its backplate, but not its rivet.

The third new discovery was made in 1997 on Cley Hill, outside Warminster, Wiltshire, and is now part of the Salisbury and South Wiltshire Museum's collections. It consists of a large crystal bead – not a clear polished one but a rather milky one – justifying the identification of crystal with 'white stone' suggested above. The bead is mounted in beaded gold strips, a rod passing through the perforation in the centre of

The Warminster jewel; actual size is 43 mm long. The gold strips on the top form a cross – the irregularity shows that it was repaired some time before it was lost. The gold backplate has a cross lightly incised into it (photographs by courtesy of the Trustees of the Salisbury and South Wiltshire Museum)

the bead to hold a small gold backplate. There is a tube with rivet holes.

On the front, the gold strips make a simple cross; in the middle is a small blue-glass domed stud, very like the one on the Bowleaze Cove jewel. Its tube is long and thin, and does not lie on the same plane as the back. The crystal bead is curved on top, but is partly flat on the back, so that it sits quite steadily on a flat surface.

Leslie Webster has observed that the crystal in the Warminster jewel is another example of reuse, like that in the Alfred Jewel, as it is likely to have been two hundred years or more old by the late ninth century. Beads like it were worn on necklaces in the early Anglo-Saxon period, and were also fixed to sword hilts, presumably as amulets for protection and for the healing of any wounds suffered by the owner in battle. It might even have been attached to some precious heirloom of the Wessex royal dynasty.

The next object to be considered was found in 1999 in Bidford-on-Avon, Warwickshire, and is now in that county's museum service's collections. It has a tube with a rivet through it, but one that is in the middle of the object, which is not flat backed. It is smaller than the other objects and different in shape. The top is a circle, deeply cut to leave three oval fields and three pellets inside, with a small concave-sided triangle at the centre, filled with black niello, a sulphide mixture. Similar circles go round the sides, alternating with panels framing niello-filled diamond shapes. So far, no one has suggested where the idea for this arrangement could have come from. The object looks like a pinhead, but no known pin has its shaft fitted into a tube and secured in place by a rivet.

The seventh discovery was made in 2005, in Aughton in south Yorkshire (it is in private ownership). It has a tube, with an empty rivet hole, and has

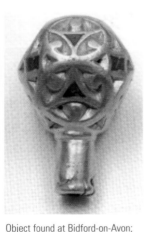

Object found at Bidford-on-Avon; actual size is 20 mm long (photograph by courtesy of Warwickshire Museum Service)

something of the Alfred Jewel about it, because it is clearly an animal's head – but not holding the tube in its jaws, and very much plainer. It has long comma-shaped ears, and eye sockets. It is not clear if there was anything in its mouth, but the shape rather suggests not. The ears are turned outwards, as are those on the beast's head on the Alfred Jewel, but unlike those on the much commoner strap-ends (see chapter 7). It also has eye sockets circled by beaded wires.

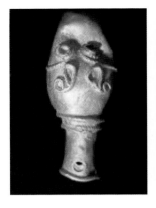

Object found at Aughton, South Yorkshire; actual size is 33 mm long (photograph by courtesy of the Trustees of the British Museum)

Other possibilities

As Simon Keynes has drily remarked, it was quite easy to believe that the Alfred Jewel was one of the *aestels* given by King Alfred to his favoured churchmen when it was unique, but, the more things comparable to it that are found, the more difficult it is to believe that so many bishops and abbots were careless about losing them.

The idea that these things were all pointers associated with King Alfred is still attractive; after all, he was distributing largesse, and it may have been priests as well as bishops who were beneficiaries. Some reading aids could even have gone to laymen, who had to learn wisdom if they were to share in the king's government. The objects may be unlike anything normally made because they were so specifically associated with the king, whose inventive mind is well testified. Four were found either in Wessex, or just outside it in territory that he controlled, but not the other three. The Bidford one is not like the others, and those from Yorkshire and Norway do not have much similarity in the way that they were made, or in their overall shape. Besides, if they were royal gifts, Alfred would surely have put his name on more than just one of them. On the other hand, all are made of gold – silver was much more common, as on the

swords and other objects shown below – and all have very individual designs, which suggests that they were special.

While only the Alfred and Minster Lovell jewels were known, explaining the tubes was not such a problem – they held some contrasting material, perhaps ivory, which was probably as prestigious as gold and was one of the precious things that Ohthere brought to King Alfred from the far north. Yet to drill through the ivory, merely so that it could have a rivet pushed through it, seems unnecessary; it was likely to shatter, and why should anyone try to pull it out? It would have been so much simpler to have a solid or sheet gold rod ending in a point, without the complication of the tube and rivet.

There may once have been an object with an inscription and a crystal like the Alfred Jewel. Two chroniclers tell how there was a shrine at Malmesbury Abbey, in Wiltshire, donated to the church by Alfred's father, King Aethelwulf, and one of them says that on it the king had placed a *fastigium cristallinum … in quo nomen eius litteris aureis …*, 'a crystal lid (or fitting) … on (in) which was his (its) name in gold letters …'. This does not give enough details, but was clearly some kind of crystal fitting with gold letters spelling out a name, more probably that of Aldhelm, to whom the shrine was dedicated, than of the king, and perhaps in niello rather than openwork, like two royal finger-rings (see chapter 3). The reference is tantalizing, but obscure.

Could all the objects taken as *aestels* actually have been shrine fittings or from caskets containing saints' and other relics? Short pegs that project from the top or sides of some of those treasures could have fitted into their tubes, but none of the early medieval survivals is known to have had that sort of fitting originally, though some were added subsequently.

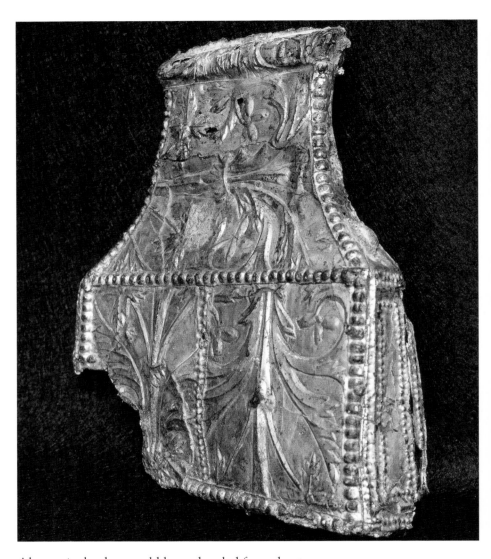

Alternatively, they could have dangled from short
chains or hooks. Some reliquaries on the Continent,
now lost, seem from drawings to have had these, but
again it is not certain that they were part of the orig-
inal fittings. And, if they were, why are objects with

The Winchester reliquary, side view. Embossed gilt copper-alloy sheets are nailed over a wooden core, in which were cavities for sacred relics. The plant pattern is symmetrical like the one on the back of the Alfred Jewel. Actual size is 175 mm high (photograph by courtesy of City of Winchester Museum Service)

flat backs, nozzles, and rivets not known on the Continent or in Ireland? Nevertheless, there are seventh-century necklaces that have animal heads with rivets through them that certainly held the end link of a chain; and there is a copper-alloy ecclesiastical censer from North Elmham, Norfolk, that has animal heads on the sides holding nozzles through which there are rivets to take suspension chains. Those, however, are soldered to the sides of the vessel, and none of the *aestels* shows any sign of having been attached to something in that way.

One reliquary from Anglo-Saxon England was excavated in Winchester, where it had been thrown into a rubbish pit either in King Alfred's reign or soon afterwards, by which time it was a hundred years or so old. It was made by nailing gilt copper-alloy embossed sheets on to a wooden core. Although a fine object, it has no provision for any fittings on to which the Alfred Jewel or anything like it could have been riveted. (This object is part of the City of Winchester Museum's collection.)

3. Royal gifts and finger-rings

Whatever an *aestel* was, King Alfred's letter prefacing the *Regula Pastoralis* shows that it was a valuable present. That the King could dispense such largesse showed his success. A leader was expected to use victory in battle to extort tribute from the losers, winning great wealth that he could share with his own people. Such rewards had long helped to cement relationships between a chief and his warriors, ensuring their loyalty in combat. The same principle came to be extended to churchmen who fought God's battle for Christian kings. One bishop called Alfred his 'ring-giver' and 'the greatest treasure-giver of all kings'.

Beowulf and other Anglo-Saxon poems often refer to 'ring-giving', so some objects may have had more significance than their weight in metal alone. 'Rings' in texts need not mean finger-rings, which became important in England only during the seventh century. Two of the finest, both now in the British Museum, are associated with members of the West Saxon royal family. They might have been given directly to a supporter, or they might have been used rather like seals, to show that a charter (a record of a legal transaction, usually a gift or sale of land) or message was authentic. If the Alfred Jewel and the others were really sent out with copies of the *Regula Pastoralis*, or with other letters from the King, they too might have been seen as identifiers, symbols to authenticate who the message came from – provided that they were recognized for what they were even without inscriptions.

The smaller ring was found at Aberford, Yorkshire. It is gold, engraved, and with black niello fused into

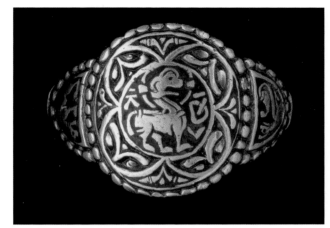

The Aberford gold and niello ring, with a drawing to show the inscription hidden on the inside. Actual size is 19 mm bezel diameter (photograph by courtesy of the Trustees of the British Museum)

the sunken areas so that the design stands out. The little creature in the centre is the Lamb of God, with the letters A and D beside it. Those are the initial letters of the Latin *Agnus Dei*, symbol of Christian baptism because of St John the Baptist's words 'Behold the Lamb of God'. The animal is an icon of Christ, so has behind its head a halo, with bars in it – Christ's halo usually has a cross like this in it, to distinguish it from a saint's.

The drawing shows the inscription cut into the back of the ring. As on the Alfred Jewel, the text begins with a cross; it then has the Old English name *Eathelswith* (the crossed Ds are Old English letters) *Reg*, with *NA* in much thinner capitals looking like afterthoughts at the end. That word would be *Regina*, showing an association with Queen Aethelswith, who was both King Alfred's sister and from 859 to 874 Queen of Mercia. The inscription may be an addition to the ring, a reminder of who it had come from.

The larger gold and niello ring, from Laverstock, Wiltshire, has the name *Ethelwulf* along the bottom – the engraver may have been copying something written out for him and not noticed that he had put

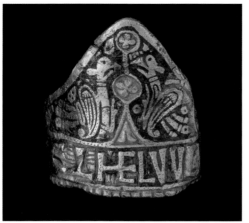

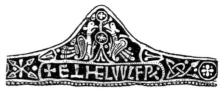

the T upside down. The text ends with an abbreviated *Rex*. King Aethelwulf of Wessex (839–58) was the father of both Aethelswith and Alfred. Above his name are two long-necked birds, both with raised legs, wings, and three tail feathers, in which little circles identify the birds as peacocks, whose tails have 'Juno's eyes'; when their tails were raised, they reminded Christians of the vault of Heaven. Between them is a device that Leslie Webster has identified as the fountain of life, as it has a cross in the circle at the top. This makes it a symbol of baptism, like the lamb on the Eathelswith ring.

Some other rings have names on them, either of their owners or of their makers. One from Bossington, Hampshire, may also be baptismal, as the inscription reads *In XPO Nomen Chlla Fic*, which may be translated 'In Christ [my] name has been made Culla'. There is no cross to show where the text starts, however, and *fic* could have other meanings. The letter for 'u' is runic.

It is not known who Culla was, so the ring cannot be dated by anything except the style of the letters, the head, and the goldwork. The first puts the ring

The Laverstock gold and niello ring, with a drawing to show the whole design. Actual size is 28 mm high (photograph by courtesy of the Trustees of the British Museum)

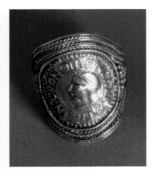

Extended drawing of the Bossington ring

The Bossington gold ring. Actual size is 30 mm bezel diameter

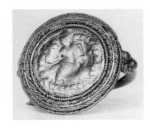

Gold ring from north London. Actual size is 23 mm bezel diameter

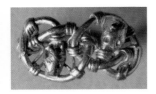

Gold ring from Dorchester, Dorset. Actual size is 24 mm hoop diameter

somewhere in the eighth to tenth centuries. The head is shown wearing a beaded circlet – possibly with a cap above – and a beaded collar. It looks as if it would not be out of place as a bust on a coin (see below), though no one has claimed one as exactly like it. The gold filigree wires and the granulation could be ninth century.

Whatever its precise date, the Bossington ring was made by a very fine craftsman, and the runic letter is enough to show that he was working in England. The twisted filigree gold wires, set side by side to make herringbone patterns, are particularly skilfully done. Included here for comparison is a ring found in north London that is earlier than the late Saxon period; the herringbone filigree surrounds a gold Byzantine coin minted in 402–50. The coin was already old when mounted, possibly in England, though the whole ring may be an import; Byzantine coins were often turned into jewellery in northern Europe in the seventh century. Another London ring (not illustrated) from Garrick Street is also very similar to the Bossington ring, but does not have the bust and inscription.

A little less craftsmanship went into making a ring bought in Dorchester, Dorset. It is uninscribed, and has plain wires, the bigger one interlaced and ending in snake-like heads. One of the eyes still has a little blue-glass stud set in it. Comparing the eye sockets in the Alfred Jewel, the larger blue glass settings at the

centres of two of the other possible *aestels* (pp. 33 and 34), and in the Pakenham spur (p. 79), makes a ninth-century date apposite.

Another gold ring with double-headed snakes and complicated wirework was bought in London by one of the Ashmolean's benefactors and is named the Joan Evans ring after her. The central boss makes an 'Anglian' round-armed cross like the Minster Lovell enamel, and the divisions of the field round it into four panels also make a cross. The very fine twisted gold wires end in clusters of tiny granules, being bitten at by the snakes. The granules are meant to be seen as clusters of grapes on a vinescroll, a favoured motif derived from Christ's words 'I am the true vine'. The snakes are eagerly devouring His words; at first glance they seem to be showing what humans should do, but as evil creatures they are threatening to swallow and destroy, because the beasts cannot comprehend the words' meaning. As with the Windsor pommel (p. 59), it is possible to read these as reminders of the threat of paganism and therefore of the Vikings.

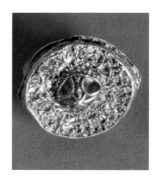

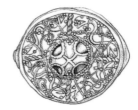

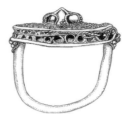

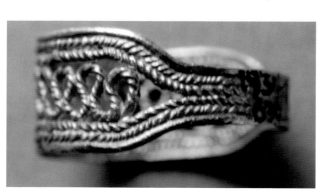

Drawings and photograph of the Joan Evans ring. Actual size is 24 mm bezel diameter

Drawing and photograph of the Coggeshall ring. Actual size is 19 mm hoop diameter

Two other gold rings are included here, though in fact they may well not be late Saxon: the first is from Coggeshall, Essex, and could be Roman; the other was bought in Oxford from a dealer who was selling a collection of Scandinavian antiquities, so the ring was probably not made in England, but in tenth-century northern Europe.

4. Hoards

The leaders of the Viking armies that so nearly over-whelmed King Alfred's Wessex in the 870s had become ambitious to take permanent control of the English kingdoms; Northumbria, East Anglia and Mercia had already fallen to them. Their followers were still as interested in getting treasure as in getting land, however, and two hoards of silver show clearly what they sought.

Some of the silver ingots, rings, and bars found in the Cuerdale hoard

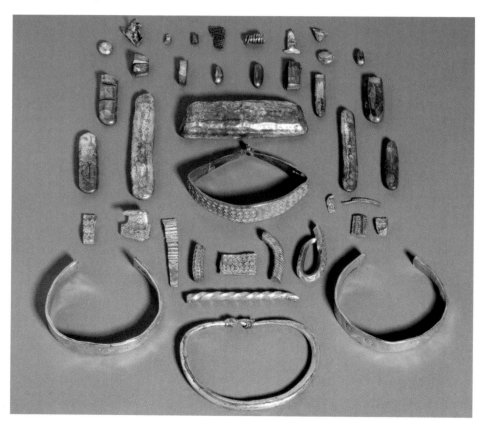

The largest hoard found was discovered in 1840 at Cuerdale near the River Ribble in north Lancashire. It consisted of at least seven thousand silver coins and over a thousand other bits of silver. The exact figure is not known, as the hoard had a mixed history after its discovery and was not all kept together. The British Museum now has most of it, but the Ashmolean has a representative selection.

The coins are not all Anglo-Saxon, though many are. The ones that had come from furthest away had been minted in the Muslim world, stretching from Spain to Iraq. A very small number had been minted in Scandinavia and others in the Low Countries and western France. Many are from the 'Danelaw' area of England, especially York and East Anglia, and from Wessex, including some minted for King Alfred. The latest coins are all from the early years of the reign of his son, Edward the Elder, so the hoard must have been deposited in about AD 905 – it is always possible that a group of coins could have been collected and not hidden until years later, but usually people add new ones and the latest coin will not be far off the date when the hoard was hidden.

The Cuerdale hoard contained a large number of silver ingots, plain and twisted rods, and rings of various sorts. Some had been stamped for decoration, but the bent and cut-up bits show why the term 'hack-silver' is used to describe things that were valued not as ornaments but as bullion. Most had come from treasures that had been melted down, but a few can be shown to have originated in Ireland, Pictland (modern Scotland), and the south of England.

The range of coins and hack-silver is typical of the sort of collection that Vikings made in their raids – they attacked first France, then England, then the Low Countries; and if they did not raid, they traded. They also traded with the Near East, which accounts

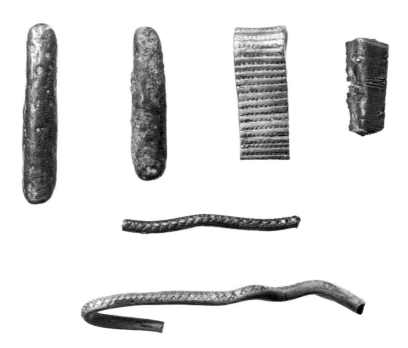

for the 'kufic' coins at Cuerdale. This is the largest hoard ever found in England, and may have been part of the wages meant for an army that was on its way to attack either Dublin or York, as the Ribble valley is a good route between the two.

Ingots and hack-silver from the Croydon hoard

Another but much smaller hoard in the Ashmolean was found in 1862 in Croydon, Surrey. It contained about 250 coins, 4 ingots and 4 pieces of hack-silver. This looks more like the property of a single individual, but even so the coins were as diverse, ranging from a few 'kufic' through Carolingian to Anglo-Saxon, including 31 minted for King Alfred, all from the first years of his reign. This makes it likely that the hoard was buried in the 870s and belonged to a Viking who had had a successful time in London, which the *Anglo-Saxon Chronicle* says an army occupied in AD 871–2.

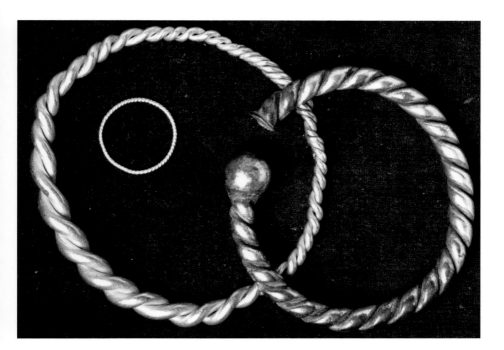

Large gold ring from Brightlingsea; silver ring from Long Wittenham; gold ring from Oxford. Actual size of the last is 18 mm diameter

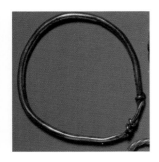

Silver ring from Deptford. Actual size is 65 mm diameter

The Ashmolean also has the only object to survive from a hoard that is said to have been found in the River Thames, near Deptford, formerly Kent. This is a large silver ring with knotted ends that was found with coins minted for Alfred's son and grandson, so was deposited in or very soon after the 930s. The ring is typical of Viking not Anglo-Saxon types; one very like it is in the Cuerdale hoard. A deep nick opposite the knot is also typical, because Vikings often tested objects and coins to see whether they were pure silver, not just base metal with a silver coating.

Ninth- and tenth-century hoards were not only deposited by Vikings. Several, particularly of the dangerous middle decades of the ninth century, contain almost exclusively Anglo-Saxon coins, and very often Anglo-Saxon objects, so must have been hidden to stop them falling into the raiders' hands. The most

famous was found at Trewhiddle in Cornwall, deposited in about AD 868, with coins and a variety of objects such as a chalice and drinking-horn mounts. Consequently its find-spot has become the name of a very distinctive style, using black niello like the two royal rings (pp. 41 and 42) and the Abingdon sword (p. 54).

Because many of the ingots and rings in the Viking hoards are not decorated, many do not get recognized if found individually. This photograph shows a number of rings of different sizes that cannot be very closely dated, but probably belong to the period. The big gold one is from Brightlingsea, Essex; the silver one with a ball terminal is from Long Wittenham, Oxfordshire; the small gold one is from Oxford, found in about 1876 when the Examination Schools were built in the High Street – not part of the original fortified area of the town, but within its eleventh-century extension. Some rings of this sort may have been made to a specific weight; very few gold coins were minted in the late Anglo-Saxon period, but they seem to have been intended to weigh three times as much as an average silver penny. So with a gold:silver ratio of about 10:1, a gold coin was worth 30d, exactly a *mancus* – King Alfred's *aestels* were nominally worth 50 *mancuses*. The gold coins weigh between 51½ and 54½ grains; the Brightlingsea gold ring weighs 757 grains, and is therefore 14.7 times the weight of the lightest known coin – so is very close indeed to the weight-equivalent of 15 *mancuses*.

Some of these rings are probably what are called arm-rings in documents like wills. They were even worn by soldiers in battle, if the texts are to be believed. The smaller ones would have made uncomfortable finger- or ear-rings, and may not have been worn as jewellery at all.

5. Swords and other weapons

For warriors in the Anglo-Saxon period, the sword was the most important weapon, though a single-edged long knife called a *seax* also carried great prestige. The best weapons had blades made by welding different strips and bars of iron together and then welding steel edges on. This knife shows how much skill went into forging and twisting the bars, then welding them into patterns.

Iron angle-backed knife. Its composition of different beaten rods of iron can be seen where it has fractured

A few Vikings who died in England were buried with brooches, weapons, and other things – a practice familiar in the early Anglo-Saxon period but one that had died out among the English during the seventh and eighth centuries, partly though not entirely because of Christianity. The Vikings who attacked King Alfred were pagans.

The sword overleaf probably belonged to a Viking; it was found in Reading, Berkshire, in 1831, with the bones of a man and a horse. The handle has copper-alloy guards at each end of the grip, decorated in a style characteristic of Scandinavian ninth-century workmanship called 'Gripping Beast', though it is so worn that the details are not clear. In 871, according to the *Anglo-Saxon Chronicle*, a Viking army 'came into Wessex at Reading. Then Ealdorman Aethelwulf ... fought against them ... and one of them, whose name was Sidroc, was killed ...'. It is very tempting to see this sword as Sidroc's, buried with the corpse

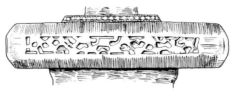

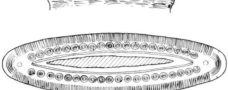

brought back from Aethelwulf's victory. That was only the first of several very vicious battles in AD 871, however, and many other Vikings were slain, or would have died later from their wounds, while the army used Reading as a base.

Whereas the Reading sword was owned by a Viking, one dredged from the River Ock at Abingdon, Oxfordshire, was owned by someone prepared to fight against him, for the ornament on its handle is certainly Anglo-Saxon. In particular, it is a very good example of the ninth-century Trewhiddle style, using black niello to fill the engraved parts of the silver strips that are on both sides of the guards, and on the carefully moulded pommel at the top. It was given to the Ashmolean in 1890 by Sir John Evans, a distinguished archaeologist whose son Arthur was to become Keeper of the Museum (and the excavator of Knossos) and whose daughter Joan was the donor of the fine gold ring discussed on p. 44.

The strips on the guards of the Abingdon sword are divided into small panels (see p. 55), each containing a different pattern. On one side are alternate plants and animals. The double-headed winged beast with fangs biting its own body in panel 24 is particularly finely done, though the double-headed snake on the

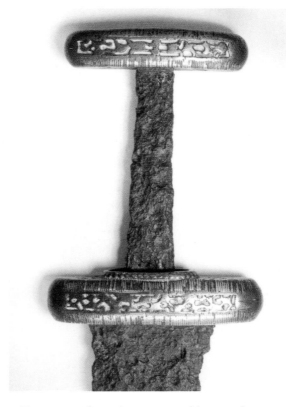

Joan Evans ring (p. 44) is comparable; in other art forms, a stone sculpture at Elstow, Bedfordshire, is very similar except in details, as is an initial letter in the *Regula Pastoralis* manuscript (neither illustrated). The single creature in panel 26 is more typical; its tail sprouts into a plant, one stem of which penetrates the creature's neck. The plant in panel 25 is a palmette leaf, ultimately derived from classical art. The one in panel 28 is symmetrical, and its flowering top and side stems are a little like the plant on the back of the Alfred Jewel.

The lower guard on the other side has only one creature, in panel 17, biting its own body like the

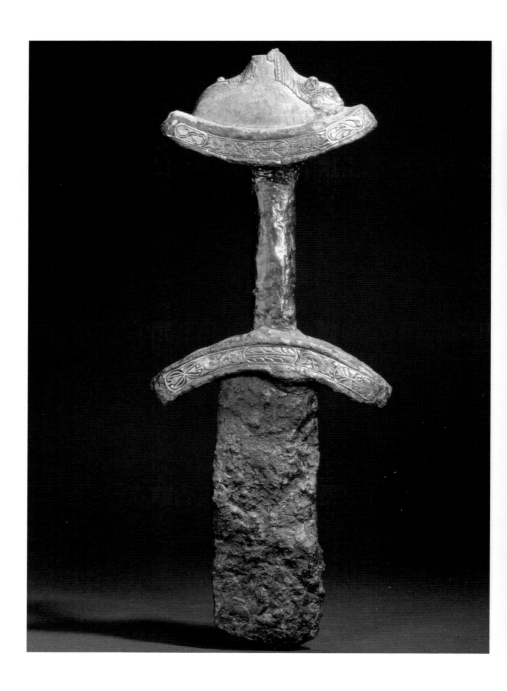

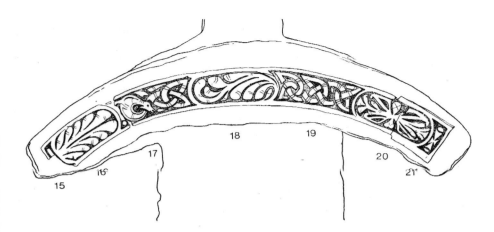

double-headed one in panel 24. Its body turns into a knot pattern very like the one in panel 19. Panels 16 and 18 are palmettes, and panel 20 is a strange plant form. Panel 9 is obviously unfinished, perhaps because the craftsman made a mistake in the preliminary engraving of the interlace and could not see how to disguise it. The creatures and plants on the lower guards might have meanings, the former being like the beast's head on the Alfred Jewel, a reminder of the threat that evil presents to God's creation symbolized

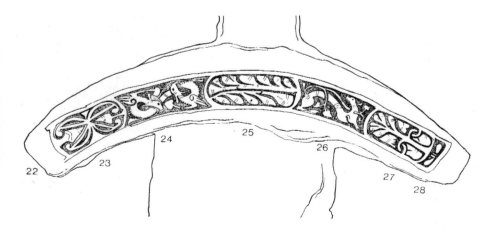

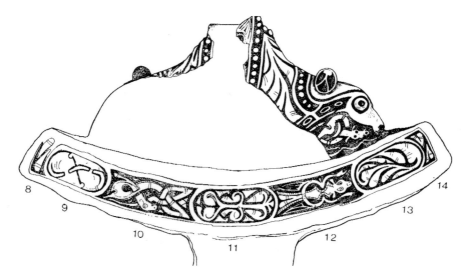

by the living plants, and by the eternity of the knot, which has no beginning or end.

Christian allusions become more direct on the upper guards. Some panels have plants, the lobed ends on the leaves in panel 6 being very like the ones on the back of the Alfred Jewel. Panel 3 has a human figure, apparently wearing boots and a loincloth, though whether otherwise naked or wearing a short-sleeved tunic is not clear; perhaps he is meant to be a reminder of Adam. In his right hand he is grasping a plant growing from the frame. Panel 6 is a bird, sitting on a tendril that 'penetrates' its neck. Its lyre-shaped wing is very like those of the two peacocks on the Ethelwulf ring, as is the shape of its tail feathers, though they do not have the 'Juno's eyes'. Furthermore, the peacocks have straight beaks, while the sword's bird has the curved beak of a raptor, strongly suggesting that it is a hunting bird.

The meaning of panels 3 and 5 becomes clearer when panel 12 is taken into account. This creature's head is more bovine than the others. It has wings on

One side of the upper guard and hilt. Missing, presumably from each side, are small gold panels, one of which was recorded in the nineteenth century

The other side of the upper guard and hilt of the Abingdon sword, with enlarged photographs of the Man and Eagle symbols in panels 3 and 5

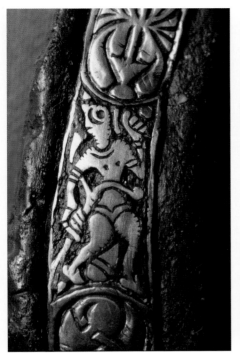
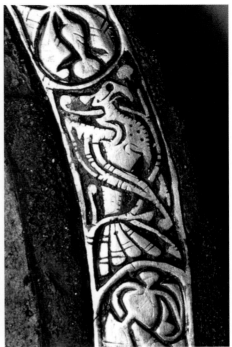
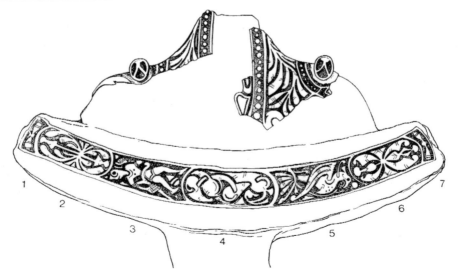

either side of its tail. These three panels are almost certainly Evangelist symbols; the Man of St Matthew, the Eagle of St John and the Calf (sometimes Bull) of St Luke. Panel 10 should be the fourth, the Lion of St Mark, but is really another creature like that in panel 17, perhaps because no metalworker knew what a lion looked like and imagined it as a fierce beast.

The Calf appears again on the pommel, above the one on the upper guard. Unfortunately the silver here is so damaged that the details are lost – a gold panel that fitted in the middle was found with the sword but is now missing. Both ends were beasts' heads; eye, nostril, and upright ear survive on one side, only ears on the other. These creatures were probably the carrion-eaters that would devour the sword's prey – 'the black raven with its horned beak, to share the corpses, and the dun-coated white-tailed eagle, the greedy warhawk to enjoy the carrion, and that grey beast, the wolf of the forest', as a poet exulting in a West Saxon king's triumph wrote after a great battle in 937.

The Four Symbols of the Evangelists were presumably to bolster the sword's owner's Christian faith and to encourage him to fight for God as well as for his king against the pagan Vikings. Superstitions may have survived, however. The Abingdon sword is one of a surprising number of weapons found in streams and rivers; of course, they might be battle losses at fords and bridging points, but it is odd that they were left behind if so. Many were bent or broken – the lower part of the Abingdon sword's blade is missing. Were they deliberately damaged, so that they could not be used again? Was there some lingering belief that they should go where they were 'useless to men', like the treasures in the old pagan traditions of burial?

Another river find, this time from the Thames at Windsor, is a solid but corroded and discoloured silver pommel, smaller than that on the Abingdon sword,

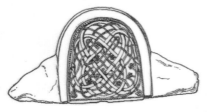

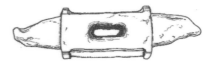

Drawings and enlarged photograph of the Windsor pommel

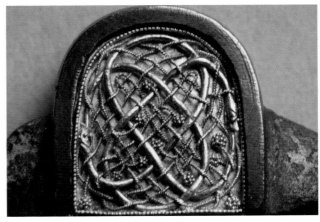

but nevertheless probably from a sword not a single-edged seax. Set into it is a gold panel (there was one on the other side as well, now missing) with a very well-executed interlace pattern. The thicker plain wires loop round and end in snakes' heads biting each other's tails. Finer twisted filigree wires wrap around them, with many ending in clusters of gold granules.

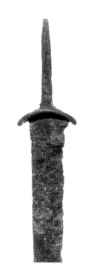

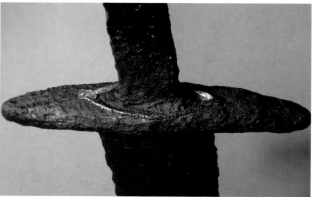

(top left) The sword from the River Thames, near Battersea. It has a scroll pattern in brass alloy inlaid into copper on the hilt, and brass wires hammered into the guard. Not visible are letters and patterns inscribed into the iron blade, probably intended as a famous maker's name, though done for good luck rather than to deceive. Actual size of guard is 110 mm wide

(left) Angled view of the Drayton sword, showing the small gilt copper-alloy fitting above the guard. Actual size of guard is 115 mm wide

(top right) The Crowmarsh sword. Actual size of guard is 86 mm wide

It seems likely that these represent grapes, another allusion to the vine and its Christian meaning, as on the Joan Evans ring. Interlaced snakes also appear in manuscripts of the late eighth and early ninth centuries, and provide dating for the pommel.

After the end of the ninth century, highly decorated and valuable sword hilts disappear from the record, though the weapons themselves remained important, and continue often to be found in rivers

and streams. One from the River Thames near Battersea, has a decorated guard and pommel, but the inlay is a brass mixture, not gold. Another, from Drayton, Oxfordshire, which was ploughed up in a field, has only a narrow lower guard, with a bright copper-alloy plate on its top. A third, from Crowmarsh, Oxfordshire, is rather similar. The reason for the decline in the amount of precious metal placed on the best swords cannot merely be poverty; more likely is that ideas about warriors going bravely into battle with such rich things were changing, and that grandiose display was not needed by leaders now confident in their place in society because of the estates that they owned.

6. Brooches

A few ninth-century hoards, like that from Trewhiddle, contain silver brooches and other objects. The Ashmolean does not have any examples of these hoards, nor of the silver brooches like those found in some of them. It has a large copper-alloy example, found in Leicester, which gives a good idea of their size – and is actually now rarer than the precious metal ones that it is copying.

The brooch is divided into four compartments, so that it forms a cross, with a boss at the centre and others at the ends of the arms, perhaps for the Five Wounds of Christ. The two that are missing did not have a practical purpose, but the others are the heads of rivets that help to secure the pin in place. The hook protruding from one side was probably to help keep the brooch in place – maybe simply to be pushed through threads in a cloak and pulled down.

Drawing and photograph of the Leicester brooch. The copper-alloy plate was given a coating of tin, so might have flashed like silver when new. Actual size is 71 mm diameter

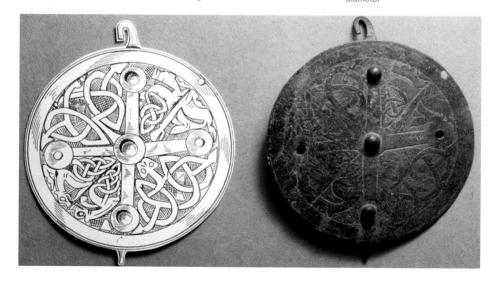

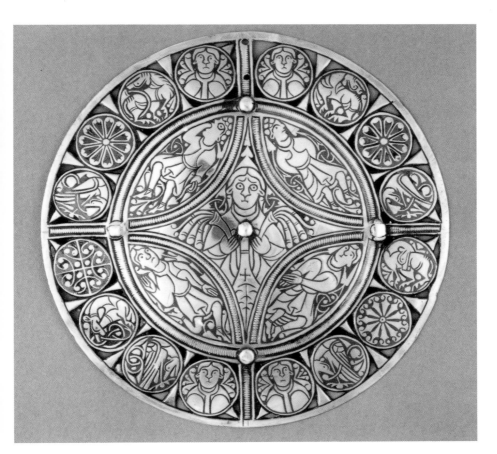

The silver and niello Fuller brooch. Actual size is 114 mm diameter (photograph by courtesy of the Trustees of the British Museum)

Contemporary pictures show men wearing round cloak-fasteners on their shoulders, but women also owned brooches, as recorded in wills, and on the back of one is an inscription that placed a curse on anyone who tried to steal it from her.

Within the arms of the cross interlaced snakes and other animals are engraved, but without niello they do not stand out as they do on silver and gold. Instead of niello, the backgrounds are hatched, leaving the creatures' bodies plain; the same technique was used on the back of the Alfred Jewel.

The Fuller brooch has already been mentioned because one of the figures on it is Sight, a parallel for the enamel figure on the Alfred Jewel. The brooch was on loan many years ago to the Ashmolean, but it is in such good condition that most people then thought it a fake, and – against the wish of one of the Assistant Keepers, E. T. Leeds, who was to become one of the greatest authorities on the Anglo-Saxon period – it was returned to its owner. It was eventually given to the British Museum, and is named from the donor, Captain A. W. F. Fuller. There is no doubt now that it is genuine; as Leeds wrote at the end of his career:

> And if you will argue that any modern forger could have evolved that idea [the Five Senses design] in Saxon spirit out of his inner consciousness, then it is as well that I should have retired to sit in the sun, as now, in my garden, and contemplate on the amount of learning that drives away common sense.

As well as Sight in the centre, the Fuller brooch has four smaller full-length figures, for the other four Senses. Taste, top left, has his hand in his mouth; Smell, top right, is sniffing a plant while ostentatiously holding his hands behind his back, so that he is distinguished from Touch, below, who is rubbing his hands together. Next is Hearing, cupping his ear and running towards the sound that has attracted his attention. Sight is more dignified, as well as larger, as befits his superior wisdom.

The outer roundels on the Fuller brooch have been interpreted as the Four Elements, earth, air, fire, and water, or as representing God's creation, birds, plants, animals, and humans, the last appearing in the superior central positions, because in the Old Testament God gave Man dominion over all the earth. Many of the details in the brooch are in the Trewhiddle style

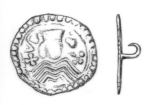

Icklingham brooch 1. Actual size is 25 mm diameter

and can be compared to the royal rings and the Abingdon sword.

A lot of smaller base-metal brooches were also worn in the later Anglo-Saxon period, many of which copied coin designs. In the eighth and ninth centuries, Carolingian coins minted on the Continent may have been allowed to circulate for use in England; at any rate, as Joanna Story has pointed out, more of them have been found than is usual for foreign coins, as English kings normally insisted that only their own coins were available. Further evidence that Carolinigian coins were well known in England is shown by this copper-alloy brooch, probably from Icklingham, Suffolk, which, although rather crudely done, seems likely to be based on a gold *solidus* minted in the reign of Louis the Pious (AD 811–40).

The Ashmolean has several other brooches and objects from East Anglia, donated by Sir Arthur Evans from the collection of his father, Sir John; he had bought them from Joseph Warren, who lived in Icklingham. As there is no record of their precise find-spots, they have been numbered here for reference, so this brooch is Icklingham 1.

Icklingham 2 is also copper alloy. Its cross pattern and toothed edge do not look very distinguished, but the cross is recognizably of the round-armed 'Anglian' type, like the one on the Minster Lovell Jewel. It is one of eight found in East Anglia, including one recently excavated at Thetford, probably lost no earlier than the end of the ninth century, but continental evidence shows that the type was well established at least a hundred years before that. Like the *solidus* copy, it is not possible to say whether this was made on the Continent and imported, or copied in England from a continental model. The cross is obviously significant, but why all the known brooches of this type have either seventeen or eighteen teeth is obscure.

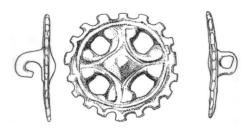

Equally obscure is why so many brooches with backward-turned animals on them have twenty-eight beads casts into their borders – Icklingham 3 has a couple more, but probably only because the mould from which it was cast had been damaged. The significance of the backward-turned animal is not clear either, but they must have been popular as many have been found, particularly in East Anglia. Their date is probably in the same range as Icklingham 1 and 2, i.e. eighth-/ninth-century, perhaps into the tenth. The other example is from Oxfordshire; its rather stringy body suggests rather a poor copy.

Icklingham 4 is more controversial. Although its ornament of a convex-sided square with scrolls around the corners is not very exciting, it has parallels in Scandinavia – both in the ninth century and in the later tenth or eleventh. Following the treaty drawn up between King Alfred and the Danish leader Guthrum in AD 878, the latter set up a kingdom for himself in East Anglia and 'shared out the land'. Much discussed is whether this means that large numbers of Scandinavians migrated into the kingdom – and into the rest of what was loosely termed 'the Danelaw' for a time – or whether the sharing-out was between the leading men of the Viking armies and a few of their followers, while the very great majority of the population remained English.

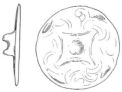

(top left) Icklingham brooch 2. Actual size is 30 mm diameter

(above) Icklingham brooch 3. Actual size is 29 mm diameter

(middle) Oxfordshire brooch. Actual size is 36 mm diameter

(below) Icklingham brooch 4. Actual size is 30 mm diameter

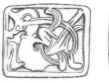

West Stow Heath brooch. Actual size is 26 mm diameter

If large numbers of migrants arrived in late ninth-century England, they should be recognizable by the changes that they would have made to the language, the behaviour and the physical culture of their new country. Icklingham 4 and, even more, this brooch from West Stow Heath, Suffolk, are part of this debate; both have some Scandinavian features, but the West Stow brooch is more distinctive because its animal, with sprawling tendrils growing from it, is in the 'Jellinge' style, which takes its name from a site in Denmark where it was first identified – although this is not necessarily where it originated. Were brooches like these made by immigrant Scandinavians, or by English craftspeople influenced by a few new ideas? And were the people who wore them necessarily Scandinavian, or English people adapting to new tastes?

Part of the answer to those questions lies in the growth of towns during the late Anglo-Saxon period: York, Lincoln, Norwich, Thetford, London, Oxford, Winchester, and many others. Brooches in the Anglo-Scandinavian styles, a term that dodges the issue of how much was English and how much was Scandinavian about them, can be seen as at least as much a reflection of new markets for people to buy trinkets in as of direct immigration from the Viking homelands.

A few big brooches continued to be made in the tenth and early eleventh centuries, but none is as splendid as the Fuller brooch. Indeed precious-metal brooches generally became fewer and fewer, just as sword hilts show less use of precious metal for aristo-cratic display. The Canterbury brooch shows the decline; although silver, the metal is not very pure. It is not a solid plate but a series of concentric beaded wires soldered together around a central disc, rather crudely strengthened on the back by silver strips. The

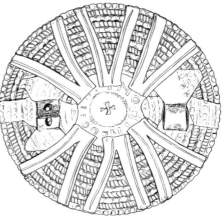

Photograph of the front and drawing of the back of the Canterbury brooch. Actual size is 79 mm diameter

hinge and catch for the missing pin are also clumsy. The strips might be later additions, as they partly obscure the Latin inscription *Nomine Domini*, 'In the name of the Lord', on the disc – but it would not have been visible when worn anyway.

The front of the brooch has another Latin inscription, *Wudeman fecit*, 'Wudeman made [it/me]'. This may be the name of the smith who made it, or it may be that of the patron who commissioned it, in the same way that the text 'Alfred ordered me to be made' commemorates the Alfred Jewel's commissioner. Wudeman is not a name that can be identified with a known person. It is set round a crowned bust like those on coins of the 960s–70s, but Kevin Leahy has recently pointed out that the disc may simply be copying classical designs, so cannot really be dated on the comparison with English coins.

Another object with a coin design is a thin lead-tin alloy disc bought in London; it probably came from a brooch, as a similar pewter disc, excavated in Northamptonshire at Sulgrave, has a backplate and traces of pin fittings. Both are embossed, Sulgrave

Two late Anglo-Saxon enamel brooches. Actual sizes

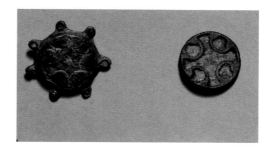

Drawing of lead-tin alloy embossed disc. Actual size is 33 mm diameter

with a Lamb of God that is similar to coins of c.1009, the Ashmolean's with a crowned bust, also like coins, and the inscription *Eadward Rex Anglorum* (the 'w' is the runic letter form, looking like P). This is probably referring to King Edward the Martyr (AD 975–9), but is not a direct copy of one of his coins. It may, therefore, be a commemorative item, from the time when he was becoming a cult figure; Shaftesbury Abbey, where he was buried, created a shrine for him in 1001, though how quickly devotion to him spread is not clear: one view is that it was not encouraged until after King Ethelred's death in 1016. It is intriguing that the two discs both seem to have religious overtones; if the Sulgrave disc dates to c.1009, there is a good chance that the Edward one does as well.

Also probably religious in meaning were small, usually copper-alloy, disc brooches with *cloisonné* enamel, making cross patterns like the two shown on p. 69. A few have faces, but not like the figure on the Alfred Jewel; they may be saints. These brooches are probably eleventh century. In the reigns of Edward the Confessor and William I, there was a vogue for mounting pennies with pin fittings; (the Ashmolean does not have any examples of these). The pennies invariably have the pins obscuring the king's head, so that it was the cross patterns on the other side that showed; both these and the enamels were probably worn as Christian 'good luck' tokens, like the *Nomine Domini* on the Canterbury brooch.

7. Some other personal fittings

Because so few people in the later Anglo-Saxon period were buried with their clothes on, let alone with things that they were not wearing but that were put in graves as offerings, the precise use or uses of many objects is unknown.

Very large numbers of strap-ends have been found, but none in the early Anglo-Saxon graves, though there is a single example from a later grave. A few were buried in hoards, as at Trewhiddle in the AD 860s, but most are stray finds, often now made by metal-detector users, or excavated from rubbish pits and other archaeological contexts.

A pair from Sutherland is probably the earliest in the Ashmolean's collection. Although found in Scotland, they are almost certainly of Anglo-Saxon workmanship. Each was made by soldering two thin strips of copper alloy together, leaving one end open so that a thin leather strap or a textile ribbon could be inserted, to be held in place either by rivets or by

A pair of strap-ends from Sutherland. Actual sizes are 53 mm long

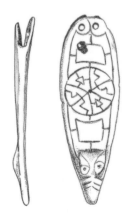 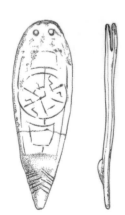

thread. At the other end is an animal head seen from above; one has eyes, but they have worn away on the other. In the middle are circles with a geometrical ornament incised on them, which is a clue to their date, as it is quite like patterns that were used on seventh-century jewellery, and then passed into the repertoire of later seventh- and eighth-century manuscript illuminators.

Many strap-ends are ornamented in the Trewhiddle style, like this one from Souldern, Oxfordshire, which is probably therefore ninth-century. It has a beast on it, its body nicked like the creatures on the royal rings and the Abingdon sword – compare panel 26 (see p.

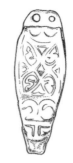

Woodeaton strap-end. Actual size is 36 mm long

Souldern strap-end. Actual size is 41 mm long

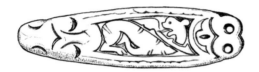

55). On the Souldern strap-end, however, a plant does not penetrate the creature's body, but cuts its head off altogether, and the front legs are clumsier. One end is split, again with two rivet holes, and the other has a beast's head, unrecognizable to anyone not familiar with others like the Sutherland pair. The Trewhiddle style puts this one into the ninth century.

Another Trewhiddle-style strap-end, from Woodeaton, Oxfordshire, has leaf ornament; it is too worn for the details to be clear, but it was probably enamelled, as there are traces of colouring in the engraved parts. It has an animal's head, again hard to identify, but with two ears that are circles with curved lines inside them. A larger one from Long Wittenham, Oxfordshire, has a clearer head, with ears like those on the Abingdon sword pommel. It also has leaf

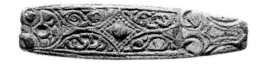

Long Wittenham strap-end. Actual size is 48 mm long

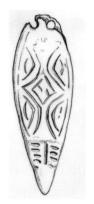

Burford strap-end. Actual size is 51 mm long

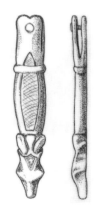

Ixworth strap-end. Actual size is 48 mm long

patterns on its main plate, slightly more elaborate and divided into four panels by a central extended rectangle. Another, from Burford, Oxfordshire, makes the head even more vestigial, and the decoration on the plate is no more than an outline, but an outline very similar to the geometrical layout on the Long Wittenham end. Are they derived from the fountain of life on the Ethelwulf ring?

Some strap-ends have only a single rivet hole, and are narrower, like this one from Ixworth, Suffolk. In this case the rivet survives. The bar across it just below the split end is not functional, but has led to the suggestion that it copies in solid metal a binding strip or twine such as might have been used on wooden strap-ends of the same sort, which would have stopped the end from opening any further. Even if that is wrong, it is a reminder that organic materials survive so rarely that the metalwork is often only a partial record of what there once was.

The main panel on the Ixworth strap-end has a sunken area, cross-hatched but not as decoration or background for a pattern, as on the back of the Alfred Jewel, but to help to 'key in' enamel or niello, now missing. Its end is much better modelled than the others, with a tiny bit of niello and silver wire in the forehead. This is a decorative technique that Gabor Thomas has identified as an East Anglian characteristic. It is interesting that regional varieties can now be seen within this large body of material.

Not in the Ashmolean, but included here because it has on it a figure comparable to the Man on the

Abingdon sword, is a silver strap-end from Cranborne, Dorset. The man seems to be struggling with a plant that is threatening to engulf him, and is wielding a knife above his head as though to cut his way free. He may be a Christian soul struggling with the snares of Hell – but alternatively may be harvesting what can be seen as a bunch of grapes, a vinescroll image like the Windsor pommel. The other close similarity to the Abingdon sword is the animal head's ears.

Silver strap-ends were deposited in hoards because they were valuable. Even more valuable, however, would have been the pair from Ipsden Heath, near Henley, Oxfordshire, which are silver but with gold plates and beaded filigree wires. They were found close together, and were obviously used as a pair, although the filigree designs are different. Both have central plant stems, one more elaborate than the other with two cup-shaped bowls or calixes – comparable to the one on the back of the Alfred Jewel. The stem is flanked by very fine scrolls making stems sprouting from a round 'bulb' at the bottom, with a gold granule in the end of each tendril. The other is more straightforward, with a succession of trumpet shapes flanked by similar scrolls.

The animal heads on the Ipsden Heath strap-ends have eyes and ears like others in the series, but have tiny gold panels with beaded filigree wires between the eyes. The wires are not quite similar to the Windsor pommel's, though the craftsmanship is of the same high quality; the difference is in the more classical balancing of the plants, as on the Alfred Jewel, rather than the intricate work on the pommel, which disguises the degree of its symmetricality.

The Ashmolean's Sutherland and Ipsden Heath strap-ends indicate that the objects were often used in pairs. The split ends are not very strong, so they would not have withstood much heavy usage, and the

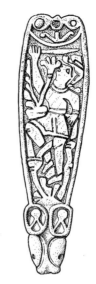

Cranborne Chase strap-end. Actual size is 65 mm long

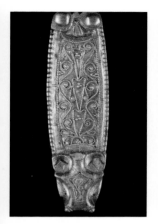

Photographs of Ipsden Heath strap-ends. Actual sizes are 57 mm long

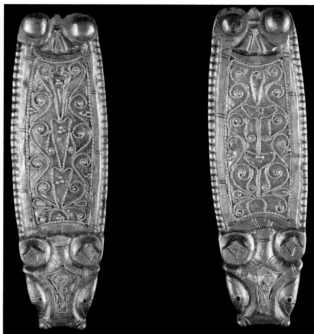

leather straps or textile ribbons that they held must have been thin and not designed to be pulled on. They seem too flimsy for sword or other belts. A few belt fittings are known from the late Saxon period, but buckles are surprisingly uncommon. One from Old Sarum, Wiltshire, has three animal heads cast into it. They are not very distinctive, and might be as early as the ninth century, but the buckle is more likely to have arrived at the Iron Age hill fort outside modern Salisbury after the beginning of the eleventh, when the place was again used as a fortified settlement.

The split-end strap-ends disappeared during the first part of the tenth century, replaced by something more robust and wider. An example from Ixworth, Suffolk, is typical in being openwork cast copper alloy; some in bone are also known. It does not have a split

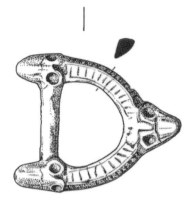

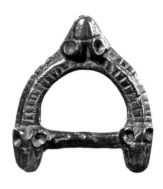

Old Sarum buckle. Actual size is 36 mm wide

end, but has four rivet holes, two now broken. It has a central plant stem with side shoots and a flower on top that is being pecked at over their shoulders by two birds. Decoration like this occurs on several objects from Winchester and the immediate area, so the idea for it may have come from there. Similar designs are found in some early tenth-century English manuscripts. An object in the same style excavated at Shakenoak, Oxfordshire, was made from thin copper-alloy sheet, and seems to have been pressed over a die to create the raised pattern.

Even more commonly found than strap-ends are hooked tags. These are usually triangular or round, and made from single sheets of silver or copper alloy, though a few are more like strap-ends but with hooks on the end.

Hooked tags have been found in a few Anglo-Saxon graves, so they came into use before the strap-ends. Their positions in the graves suggest that some at least were on clothing, particularly at the

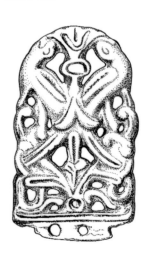

Ixworth strap-end. Actual size is 53 mm long

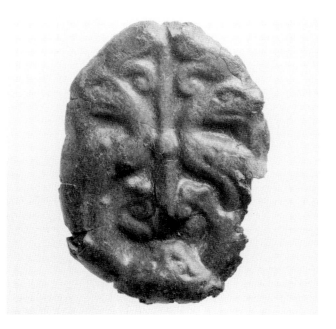

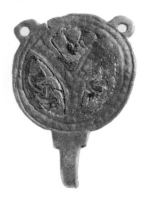

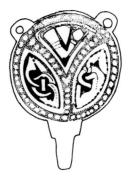

Drawing and photograph of silver and niello hooked tag from near Bampton, Oxfordshire. The two knot patterns, and the leaf pattern at the top, can be compared to panels on the Abingdon sword. Actual size is 20 mm diameter

ends of sleeves. They almost invariably have two holes at the top, so that they could be sewn into place. Presumably they could be hooked into an 'eye', made of thread not metal. The latest date for them is eleventh century, as two have been found in cemeteries used at that time for executions. By then, they were also probably being used to sew on to small bags or purses, the likely reason why two were found in Rome with early tenth-century English coins (not illustrated). Those tags were inscribed with the name of Pope Marinus (942–6); it was a long-established custom for English kings to send annual payments to the papacy, and the bag or purse containing one of them was probably mislaid.

A broken strip of silver from Cricklade, Wiltshire, may be from a hooked tag, though it is not quite symmetrical and may have come from some other fitting. It has a good-quality Trewhiddle-style animal biting at

a plant. Cricklade is up-stream of Oxford on the River Thames, and is similar to it also in being a place mentioned for the first time in a late-ninth- or early tenth-century document as one of the places fortified by the people of Wessex, as was Winchester.

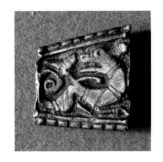

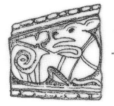

Enlarged drawing and photograph of the Cricklade fragment. Actual size is 10 mm wide

8. Riding equipment

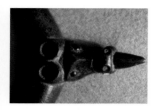

Photograph of the top of the animal's head on the Pakenham spur, showing the two small blue-glass studs in its eyes – larger ones might have been fitted into the beast's on the Alfred Jewel. The head holds a pointed metal rod, another possible parallel

Photograph of the whole of the Pakenham spur

A few early Anglo-Saxons were buried with horses, or just with horse's heads, and some elaborate bridle fittings are known. More prosaically, horse bones occur in small numbers in most middle Anglo-Saxon occupation sites. Riding may have been an aristocratic prerogative at first, but became commoner. There were enough horses in ninth-century England for Viking raiders to be able to land and then steal some of them in order to raid inland from bases like Reading.

This object from Pakenham, Suffolk, is probably a spur, one of the first since the Roman period. It is made in cast copper alloy, and has widely splayed arms and a flat back. The animal head at the end holds a short pointed rod, and the whole thing sits so well on a flat surface that identification of it as an *aestel* was once suggested. The animal-head terminals are like

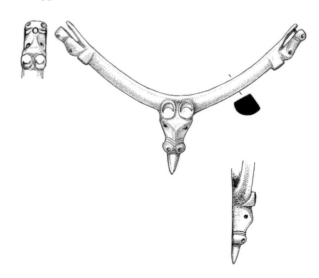

Drawing of the Pakenham spur. The side view shows the flat back, unusual for a spur. Actual size is 74 mm wide

Drawings of later spurs. Left, from Bruern Abbey; right, from Ixworth

those on strap-ends, except that rivets pierce their open mouths. Several of the eyes still contain their blue-glass studs, like those on the Aughton jewel. The ears are like those on the pommel of the Abingdon sword. These details justify claiming a ninth- or early tenth-century date for the object, and, as later spurs are mostly iron and have very different terminals, some doubt over the function of this object remains.

By the eleventh century, iron spurs with longer arms and prick-goads were the norm; many, like this one from Bruern Abbey, Oxfordshire, were plain but had a coating of tin, partly to preserve the iron from rust but probably more importantly to flash in sunlight. The Bruern Abbey spur has two rivet holes in its terminals, and a leather strap was attached by clamping it to an iron plate. The alternative, as on this one from Ixworth, Suffolk, was a rectangular slot on which a buckle swivelled. The criss-cross decoration gave variety but also helped to hold the tin coating in place.

A spur found at Magdalen Bridge, Oxford, was

Stirrups from Magdalen Bridge, Oxford, with brass-mixture decoration. Actual size of the larger is 237 mm high

reported to have been found with two stirrups, and horse and human bones, and was for long thought to be the remains of a Viking buried after the infamous St Brice's Day Massacre of the Danes, who were in Oxford in 1002. Burials of that type had probably ceased in Scandinavia by that date, however. The Magdalen Bridge, Oxford, stirrups were presumably worn as a pair, though they do not quite match. They have brass-mixture scroll decoration beaten into their surfaces. This is good-quality work, but not exceptionally skilful, and the stirrups are like the tenth- and eleventh-century swords such as that from Battersea (see p. 60) in not having precious metal on them.

The Ashmolean has on loan a stirrup from Chalgrove, Oxfordshire, which has triangular arms,

ending in animal heads. At its top it still has a copper-alloy mount that helped to fit the leather strap to the stirrup. Many examples of the animal-head terminals have been recovered by metal-detectorists, and even more of the mounts – as they were held in place only by rivets, they came off very easily.

David Williams has shown that there are many different types of these late-tenth- and eleventh-

Photographs of the Chalgrove stirrup, showing the mount at the top and details of the animal's heads at the junctions

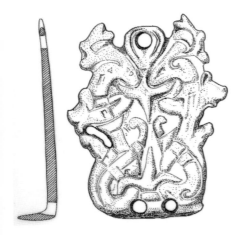

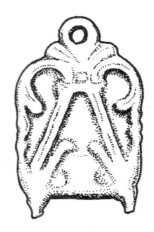

(above) Drawing of the Mildenhall stirrup-mount. Actual size is 53 mm long

(above right) Drawing of the Hampton Gay stirrup-mount. Actual size is 53 mm long

century stirrup mounts. The Ashmolean has one from near Mildenhall, Suffolk, with rather worn tendrils in the Ringerike style – a Scandinavian name, but a style that was certainly used if not devised in England, and by craftsmen who had not been born in Scandinavia (compare the earlier Jellinge brooch, p. 67). Another is also from Oxfordshire, from Hampton Gay, and has plant ornament a bit more like that of the cast open-work strap-ends.

These fittings used to be quite rare, and were thought to be from book covers. Now they are known in their hundreds, but are no less important for having a more prosaic function, as they show that very many people were riding in late Anglo-Saxon England and that horses had everyday uses such as going to market, not just the eye-catching purposes recorded in documents such as carrying the king's messages or going to fight in his battles – though it remains true that there is no evidence that the Anglo-Saxons ever fought on horseback, a reason for their defeat at the Battle of Hastings in 1066.

9. Enamel mounts

The Alfred Jewel used *cloisonné* enamel, but a more common technique is called *champlevé*, in which the enamel is floated into sunken areas in a cast plate. Some of that work can be very high quality, as this early tenth-century disc from Brasenose College, High Street, Oxford. Its colours have faded, but the drawing shows the details: a round-armed cross and four long-necked birds in contorted positions that can be seen as a development from the Trewhiddle style, like those in four of the roundels on the Fuller brooch, and are also found in early tenth-century manuscript initials.

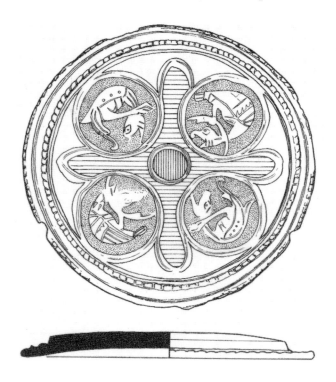

Drawing of the enamel disc from Brasenose College, Oxford. Actual size is 64 mm diameter

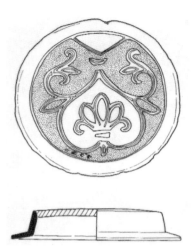

Drawing of the enamel disc from St Martin's, Oxford. Actual size is 50 mm diameter

The late eleventh-century Bayeux Tapestry also has birds a bit like them.

Another *champlevé* enamel disc, from St Martin's Church, Carfax, Oxford, has a palmette plant design, with tenth- and eleventh-century parallels.

It is not known what these two enamels came from. They do not seem to be brooches, as they do not have pin fittings on the back, and the flange of the St Martin's mount suggests that it was to fit into a roundel, possibly on a shrine. It may be coincidence that both were found in Oxford, but, despite recent metal-detecting, nothing quite like them has been reported from anywhere else. Possibly there was a workshop in Oxford making them.

10. Coins

The Icklingham 1 brooch imitates a continental gold coin, but, so far as is known, King Alfred did not follow the example of a few of his predecessors by minting some very special gold coins. He maintained the currency of silver pennies, and introduced round silver halfpennies. The designs of his coins changed from time to time and the precise dates when particular ones were issued is not completely agreed. In the early part of his reign, his coins were very similar to those of the King of Mercia, Ceolwulf II – despite the *Anglo-Saxon Chronicle*'s dismissive description of him as 'foolish' because he was to be seen as a puppet of the Vikings. This cooperation over the coinage makes it less surprising that the Alfred Jewel's inscription uses Mercian spellings.

Alfred took steps to raise the value of his coins by increasing both their weight and the proportion of silver in them; this seems to have happened before his victory over Guthrum in 878, so even though his position was precarious, he saw the importance of having a strong, trustworthy currency, and still had enough reserves of precious metal to obtain which may explain why people were still prepared to support him despite his precarious position up to that event.

Another aspect of King Alfred's coins is that a number of them carry the name of the mint where they were struck. He increased the number of places where minting took place. One of these was probably Oxford, with a penny inscribed *Orsnaforda* on one side, which is the earliest record of the name. This side has *Elfred* across the middle, presumably the king's name without an 'A', which is suspicious and has led to the coin being taken to be a less than

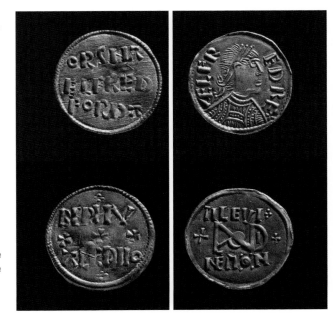

(left) Obverse (above) of silver penny with *Orsna/Forda* divided by the name Aelfred, and the moneyer's name *Bernw/ald*, followed by *Mo* for *moneta* on the reverse (below). Actual size is 19 mm diameter

(right) Obverse (above) of silver penny with *Aelfred Rex* round a head – not wearing a crown or a helmet, but a diadem, showing that the design was copied from Roman coins. The reverse (below) also shows Roman influence in the central monogram formed from the letters *Londini*, for London with the moneyer's name *Tilewi/ne Mon* above and below. Actual size is 20 mm diameter

perfect copy of a genuine penny; a lot were imitated in the 'Danelaw'. The coin is now thought to be from the late 870s, and a genuine issue by King Alfred – even though it lacks the royal title (above).

Coins minted in London by King Alfred have usually been seen as celebrations of his capture of the city, in 886 according to the *Anglo-Saxon Chronicle*, but Simon Keynes has argued persuasively that he had control of it before that date, possibly by the late 870s. Alfred also issued coins from Gloucester, so he was showing his increasing power by the political statement of minting in his name at three of the most important centres in southern Mercia. He was claiming to be dominant beyond the frontiers of Wessex.

11. A reliquary

A cast copper-alloy reliquary found in Sandford,
Oxfordshire, is the only one of its kind. On the front,
in relief, is the figure of Christ, with a cruciform halo,
His left hand resting on the Book of Judgement with a
loop of drapery above it and His right raised in
blessing. He is robed, and one part of the garment
flutters out to the (viewer's) right, a frequent late
Saxon trait. He is seated on the Rainbow of Heaven,
an image from the Old Testament of Noah's foreshad-
owing of redemption. There are two bosses to either
side, which are not functional. Above Christ's head is
a bird, probably for the Holy Spirit; it forms a looped
handle, so that the object could be suspended. Round
the side is a Latin inscription, *Intus quod latet cuncto
nos crimine laxet*, a leonine hexameter meaning: 'May

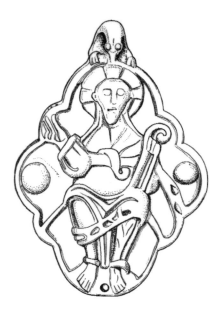

Drawing of the front of the
Sandford reliquary. Actual size is
73 mm high

Drawing of the sides of the
Sandford reliquary, showing the
inscription

what is hidden within release us from sin.'

There is now no backplate, and the area behind
the cast figure is hollow. The inscription suggests that
the object was a reliquary for some sacred item that
could offer salvation, to be kept concealed within the
object. No other cast bronze reliquary is known,
though there are some in ivory. It was either to be
hung above an altar, or to be worn as a token of per-
sonal devotion. Christ's draperies suggest a date in the
eleventh century, but the moulding of the figure is
more solid than on most Anglo-Saxon work, and it
may well post-date the Norman Conquest. It certainly
foreshadows Romanesque work, and therefore provides
a fitting end to this booklet.

12. Finale

The Sandford reliquary may be the last Anglo-Saxon object in this Handbook, but a note to explain why some things have not been included until now is appropriate.

When the Ashmolean's catalogue of later Anglo-Saxon metalwork was published in 1974, it contained one thing that I had already begun to realize should not have been included in it. That was a small copper-alloy buckle plate with an embossed lion on it; an excavation of a later medieval site on the route of the then new M40 motorway had just brought to light a plate with a little dog embossed on it that was horribly similar. The other buckle plate shown here, with the scroll, is also probably later medieval, though the case is more arguable.

Buckle plate with embossed lion, probably thirteenth century. Actual size is 24 mm wide

More interesting is the silver pin (opposite) with very fine filigree on the head. This was compared to various beads and other items, and a case for a late Saxon date was credible in 1974. Twenty years later, however, Sue Margeson showed that there were indeed pins like this in northern Europe at that time, but this is not one of them. Pins with globular heads became popular again in the fifteenth century, and were probably still being made in the seventeenth. They have filigree circles on the heads, containing three smaller circles – like the one in the Ashmolean. If that had been Anglo-Saxon, it would have had spiral or free-flowing filigree like the workmanship on the Joan Evans ring or the Windsor pommel. In mitigation, I did note that the punched technique was unusual, but I did not draw the right conclusion.

Buckle plate with cast plant in relief, perhaps twelfth century. Actual size is 35 mm wide

It will always be difficult to be certain about some things. The Oxford finger-ring has been included in

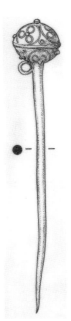

this booklet so that it can be seen with the other rings, but, as it is probably Scandinavian, excluding it from the 1974 catalogue was academically correct. Typical of academic thinking was to see as book-cover mounts things that have since been shown to have a very non-academic purpose on stirrups. Ideas and identifications change with new material and new approaches to thinking about it. Nevertheless, and despite three centuries of study, the function and the original ownership of the Alfred Jewel remain undetermined. There would be less to enjoy about it if the debate were closed.

Silver pin, probably fifteenth/seventeenth century. Actual size is 73 mm long

Bibliography

Many publications have discussed the Alfred Jewel; the list in the 1974 Ashmolean catalogue was fairly complete, and contains the references up to 1970 mentioned in this Handbook. The list that follows contains the works cited in the Handbook, and a couple of others that are particularly relevant.

Brooks, N. P., and Graham-Campbell, J., 'Reflections on the Viking-Age Silver Hoard from Croydon, Surrey', in M. A. S. Blackburn (ed.), *Anglo-Saxon Monetary History* (Leicester: Leicester University Press, 1986), 91–110.

Graham-Campbell, J., 'The Re-Provenancing of a Viking Age Hoard to the Thames, near Deptford (S.E. London)', *British Numismatic Journal*, 56 (1986), 186–7

Hinton, D. A., *A Catalogue of the Anglo-Saxon Metalwork 700–1100 in the Department of Antiquities, Ashmolean Museum* (Oxford: Clarendon Press, 1974).

—*Gold and Gilt, Pots and Pins: Possessions and People in Medieval Britain* (Oxford: Oxford University Press, 2005).

Howlett, D. R., 'The Iconography of the Alfred Jewel', *Oxoniensia*, 39 (1974), 44–52.

Kempshall, M., 'No Bishop, no King: The Ministerial Ideology of Kingship and Asser's *Res Gesta Alfredi*', in R. Gameson and H. Leyser (eds.), *Belief and Culture in the Middle Ages* (Oxford: Oxford University Press, 2001), 106–27.

Keynes, S., 'The Discovery and Publication of the Alfred Jewel', *Somerset Archaeological and Natural History Society Proceedings*, 136 (1992), 1–8.

Leahy, K., 'Anglo-Saxon Coin Brooches', in B. Cook and G. Williams (eds.), *Coinage and History in the North Sea World*, c. AD 500–1250 (Leiden/Boston: Brill, 2006), 267–86.

MacGregor, A., 'A Pair of Late Saxon Strap-Ends from Ipsden Heath, Oxfordshire', *Journal of the British*

Archaeological Association, 147 (1994), 122–7.

—A Summary Catalogue of the Continental Archaeological Collections (Roman Iron Age, Migration Period, Early Medieval) (Oxford: British Archaeological Reports International Series 674, 1997).

—and Bolick, E., A Summary Catalogue of the Anglo-Saxon Collections (Non-Ferrous Metals) (Oxford: British Archaeological Reports British Series 230, 1993).

Margeson, S. Norwich Households. Medieval and Post-Medieval Finds from Norwich Survey Excavations 1971–78, East Anglian Archaeology 58 (1993)

Story, J., Carolingian Connections: Anglo-Saxon England and Carolingian Francia, c. 750–870 (Aldershot: Ashgate, 2003).

Thomas, G., 'Silver Wire Strap-Ends from East Anglia', Anglo-Saxon Studies in Archaeology and History, 9 (1996), 81–100.

Webster, L., 'Aedificia nova: Treasures of Alfred's Reign', in T. Reuter (ed.), Alfred the Great (Aldershot: Ashgate, 2003), 79–103.

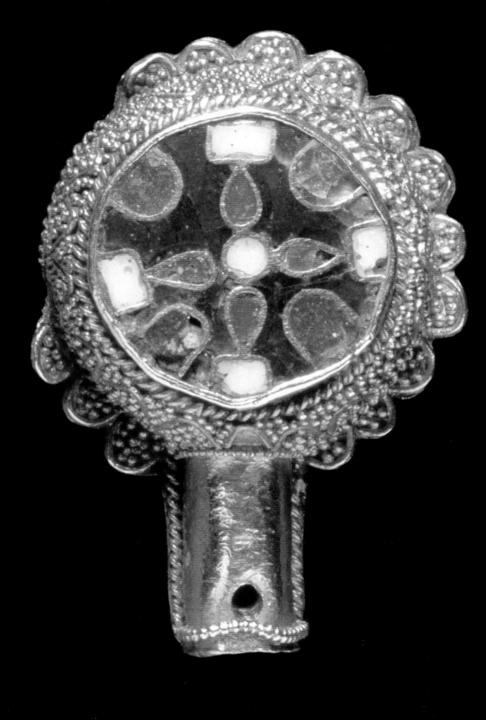